SELKIRK & MELROSE
THROUGH TIME
Jack Gillon

AMBERLEY

First published 2017

Amberley Publishing
The Hill, Stroud, Gloucestershire, GL5 4EP
www.amberley-books.com

Copyright © Jack Gillon, 2017

The right of Jack Gillon to be identified as the
Author of this work has been asserted in accordance with
the Copyrights, Designs and Patents Act 1988.

ISBN 978 1 4456 7300 4 (print)
ISBN 978 1 4456 7301 1 (ebook)

British Library Cataloguing in Publication Data.
A catalogue record for this book is available from the
British Library.

Origination by Amberley Publishing.
Printed in Great Britain.

Acknowledgements

Special thanks to Eileen and Andy Moir for all their help and for providing very welcome refreshments. Andy was an enthusiastic and knowledgeable guide to Selkirk – he also took the photograph of the 2017 Casting of the Colours. Andy is a talented local artist who has a studio at the Haining.

We stayed at the very comfortable Bow Cottage in Melrose during our visit. Louise, the owner of the cottage, was more than helpful and a stay there is recommended if you are visiting the area. It seems that Little Fordel, beside Bow Cottage, was Melrose's school before the Grammar School was built and that Bow Cottage was the headmaster's house – so we were living a piece of Melrose's history.

Thanks to Dorothy Shepherd for providing the Glenlivet and acting as navigator on visits to the local villages. Toby also encouraged me to have a walk around the towns.

I would also like to thank all the people that I met on my visits who were always happy to give me directions and pass on local knowledge. It gave the impression that Borders' folk were a friendly lot.

As always, I'm forever grateful to my wonderful wife, Emma Jane, for her patience and support.

Introduction

'The habits of the people of Selkirk are cleanly, their houses comfortable, and kept in good order; while their dress, without manifesting any peculiarity, is much attended to. Strangers invariably remark the neat and decent appearance of the lower orders on Sundays. Their food is good and wholesome, the bread in the country being mostly made of pease or barley, and in the town from wheat; and there are few families that have not butcher-meat almost every day to dinner - potatoes are in constant use. They are much addicted to the smoking of tobacco. They are, for the most part, well-informed, disposed to religion, sober, and respectful. Drinking of spirituous liquors, which was of late years very common, has in a considerable degree declined – and the only crime prevalent is that of poaching, which is carried on in game to a great extent.' (*The New Statistical Account of Scotland*, 1845)

Selkirk has a long history, but few traces remain of its twelfth-century royal castle or its abbey, the first in the Borders, which was founded in 1113 and survived until 1128. The derivation of the name is given as from 'the Celtic *Scheleckgrech* meaning the Kirk in the wood or forest'. Selkirk obtained its original charter in the twelfth century from David I and it is one of the oldest burghs in Scotland.

Shoemaking was an early industry and the town's inhabitants are traditionally known as Souters (cobblers). The Selkirk Souters supplied 2,000 sets of boots for the army of Bonnie Prince Charlie in 1745, although the result went the wrong way at Culloden and the prince defaulted on payment.

The nineteenth century was a period of expansion when the traditional cottage-based industries of spinning and weaving were overtaken by new large factory mills producing high-quality tweed and tartans. The mills took advantage of wool from local farms and the water power of the Ettrick.

The town remains proud of its history. The Selkirk Common Riding in June is an enthusiastic celebration of the town's traditions and links to the Battle of Flodden.

'The people of Melrose, without being distinguished from their countrymen by any personal peculiarities, may be described as being generally a stout, muscular, well-formed race, hardy and patient of fatigue, having among them many in stances of great stature and strength. The dress of the common people, from which every peculiarity has long ago disappeared, is always becoming, and in good repair: and on particular occasions, when they appear in their "Sunday's best," it differs little from that of the upper classes. For some years past, they seem to have been rather in straitened circumstances, owing to the low rate of wages, and the scarcity of work; but by industry, temperate habits, and frugal management, they make a shift to maintain themselves and their families comfortably; and there are few of them who have not saved a sum of money, upon which they can draw in any emergency. It may be truly said, that they are an intellectual, moral, and religious people; and that, through the excellent education which they universally receive, and their natural capabilities, they are becoming more so every day.' (*The New Statistical Account of Scotland*, 1845)

There's Aye Something to Blaw About in SELKIRK

The name Melrose is derived from 'Mailros', 'the bare peninsula', which relates to the original site that stood a few miles downstream from the present town in a loop of the Tweed.

The town grew around the abbey in a picturesque location near the Tweed with a backdrop of the Eildon Hills. Industry was limited to the manufacture of linen, which thrived during the mid-eighteenth century, but was soon overtaken by larger-scale manufacturing in Galashiels.

Melrose developed as a prosperous, peaceful and easy-going market town with an array of hotels to cater for visiting tourists attracted by the scenery, the abbey and the association with Sir Walter Scott. The internationally renowned Melrose Sevens Tournament also attracts visitors to the town.

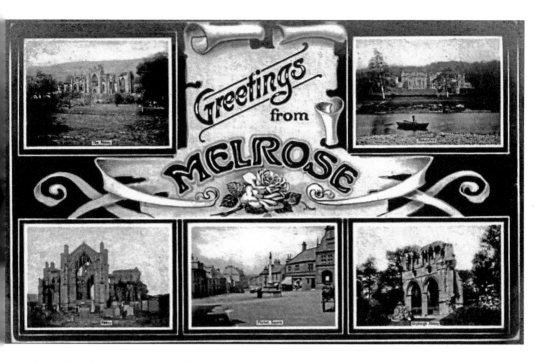

Selkirk and Melrose Postcards

The many historic associations of Selkirk and Melrose and the fame of Sir Walter Scott made the towns and the surrounding areas immensely popular with tourists from the mid-nineteenth century. These two old multiview postcards of Selkirk and Melrose show some of the attractions in and around the towns. In Selkirk: the Pot Loch, Bowhill, the Ettrick and the Flodden Memorial. In Melrose: Market Square, the abbey, Dryburgh Abbey and Abbotsford.

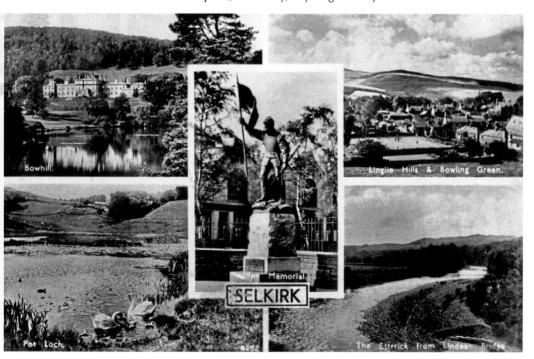

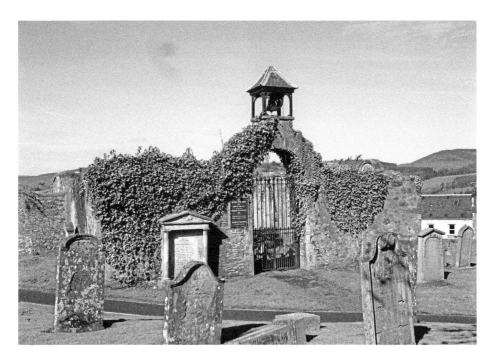

The Auld Kirk, Selkirk

The site of Selkirk's ruinous old parish church has been occupied by religious buildings since the mid-twelfth century. The original building, the 'forest kyrk' (Kirk of the Forest), was the reputed location where William Wallace was made Guardian of Scotland in 1298, after he defeated the English at the Battle of Stirling Bridge.

The original building was demolished in the sixteenth century and a new building was erected. This was replaced by the existing building in 1747, which functioned as the parish church until 1861, when St Mary's West at Ettrick Terrace was built as the new parish church. The graveyard contains many interesting early headstones and several gravestones of the maternal ancestors of President Franklin D. Roosevelt.

The image of Wallace is a detail from the statue on the Bemersyde Estate, near Dryburgh.

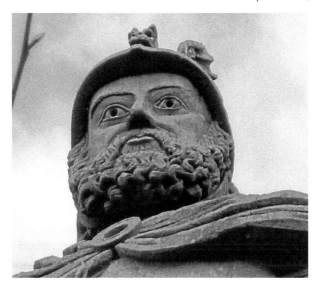

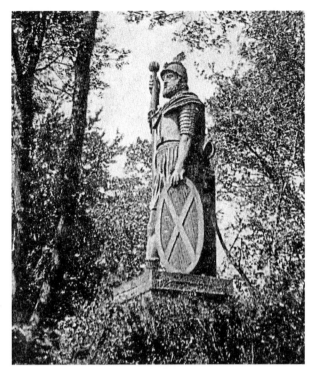

The Wallace Statue, Dryburgh

The 9.5-metre- (31-foot) high formidable red-sandstone statue of William Wallace on the Bemersyde Estate, close to Dryburgh, was unveiled on 22 September 1814, the anniversary of the Battle of Stirling Bridge in 1297. It is the earliest memorial to Wallace. It depicts Wallace looking towards the Ettrick Forest, dressed in armour, resting on his double-handed sword, with a huge Saltire shield at his side. The pedestal is inscribed: '*Wallace/ great patriot hero/ill requited chief/ MDCCCXIV*'.

It was the work of local sculptor John Smith of Darnick and commissioned by David Stuart Erskine, 11th Earl of Buchan. There is something slightly odd about its proportions and it was not universally appreciated – Sir Walter Scott described it as a 'horrible monster'.

The earl was passionate about Scotland's history and founded the Society of Antiquaries of Scotland. He was also keenly interested in Greek mythology and was responsible for the Temple of the Muses, which stands downhill from the statue.

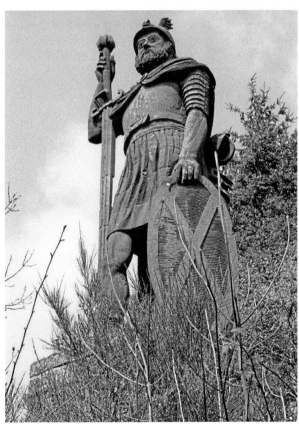

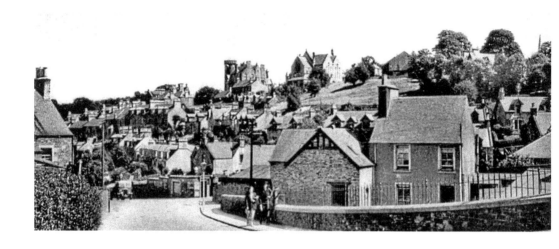

Selkirk from The Green

These two views of Selkirk taken from The Green are separated in time by over 100 years. The round tower of the County Buildings is prominent on the skyline of both images. St Mary's Parish Church, which dated from 1862, is the other main feature of the skyline in the older image; it was demolished in 2004 after being redundant for over twenty years.

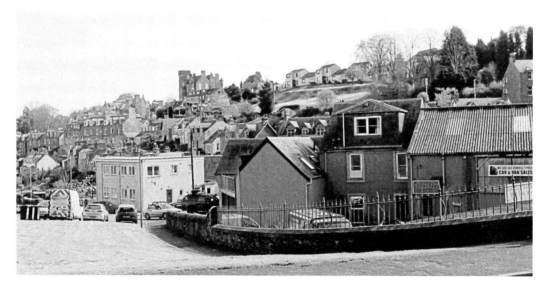

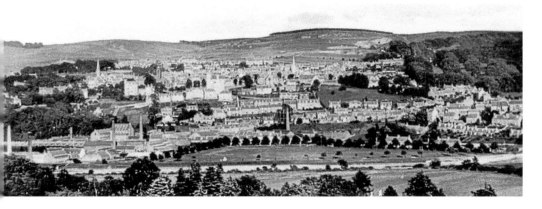

Selkirk Views I

'Selkirk, a post and market town, a royal and parliamentary burgh, and the county town of Selkirkshire, is situated on a rising ground flanking a fine haugh on the right bank of the Ettrick Water. Its site on an eminence, rising from 400 to 619 feet above sea-level, is eminently favourable for sanitary arrangements; and its environs comprise the beautiful pleasure grounds of Haining and picturesque reaches of the Ettrick and Yarrow Waters to Oakwood Tower and Newark Castle.' (F.H. Groome, *Ordnance Gazetteer of Scotland*, 1882–84)

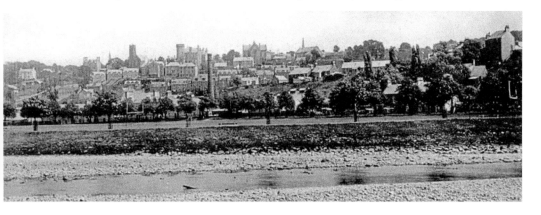

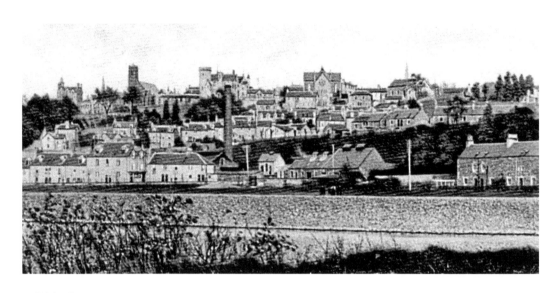

Selkirk Views II

Views looking over Selkirk from the river. The tall chimney of the gasworks is prominent in the earlier image. Skyline features in the earlier image from left to right are: Ettrick Lodge, the Lawson Memorial Church spire, the West Church tower (demolished 1983), the round tower of the County Buildings, St Mary's Parish Church (demolished 2004) and the Baptist Church.

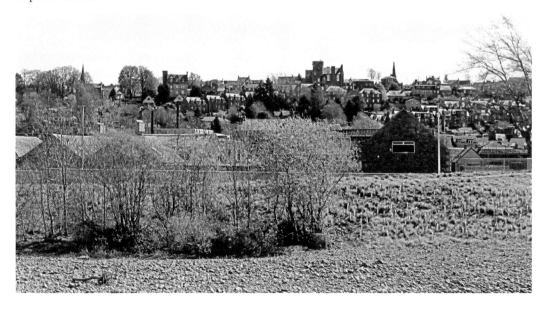

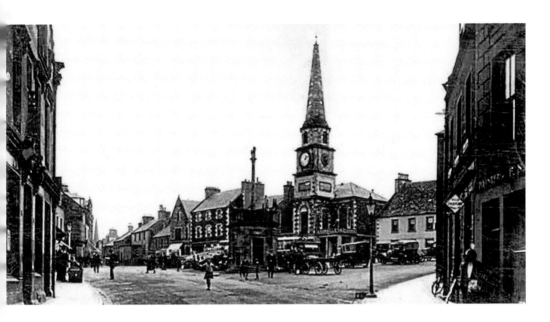

Selkirk Market Place I

These two early views of Selkirk Market Place from the top of West Port take in the Pant Well, the Town House and the statue of Sir Walter Scott. Market Place with its distinctive and spacious medieval triangular plan would have been a bustling place with regular fairs and markets. It remains at the core of the town and is now surrounded by a fine collection of mainly nineteenth-century buildings.

The Fleece Hotel building, which can be seen on the left of the lower image, dates from the early nineteenth century. In 1823, it was known as Mr Allan's Inn – at that time Ettrick Terrace had not been built and there was a building linking the inn to the property opposite. By 1858, Ettrick Terrace had been formed. The inn went through a number of name changes: it was William Mill's Inn (1870), Mill's Fleece Hotel (1880) and Gilbert's Fleece Hotel in the picture shown, which dates from the 1900s.

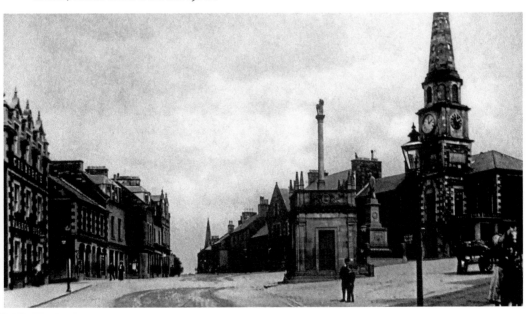

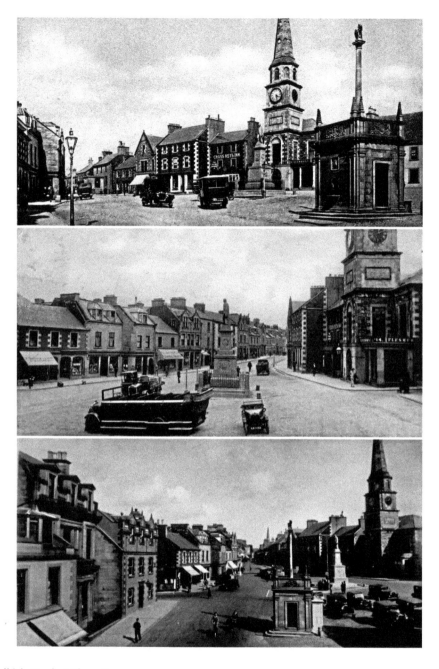

Selkirk Market Place II

Three older images of Market Place from the top of West Port, which illustrate the arrival of motor transport to the town. A charabanc awaits passengers in the middle image. Regular adverts in the early 1920s in the *Southern Reporter* provided details of charabanc tours leaving from Market Place: Berwick on Tweed for 15s, Solway Firth by way of St Mary's Loch, Moffat, Lockerbie, Gretna and Annan for 14s 6d and Dunbar for 15s – the service was provided by Robert Stark, No. 1 Railway Station, Selkirk. In 1923, the Border's Motor Company was providing a charabanc round trip taking in Selkirk, Gala, Melrose and St Boswells for 4s 6d (although it only ran if sufficient people booked).

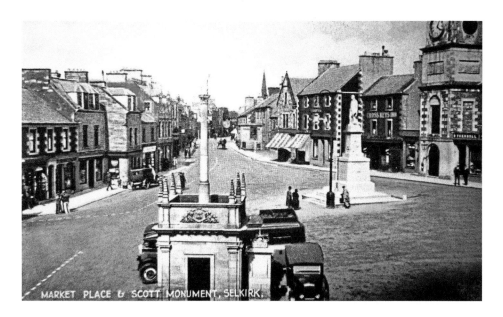

MARKET PLACE & SCOTT MONUMENT, SELKIRK.

Selkirk Market Place III

The Cross Keys Inn is prominent in the earlier image. Selkirk has always functioned as an important retail centre for the surrounding countryside. In 1863, Selkirk's retail offer included eight grocers, four bread, biscuit and fancy biscuit makers, a meal and flour dealer, two watchmakers and jewellers, an agricultural implement maker, two saddlers, four boot and shoemakers, a veterinary surgeon, five tailors and clothiers, a hairdresser, a dealer in china and crystal, three fleshers and a bookseller.

Halliwell's Close, which leads off Market Place, takes its name from Robert Halliwell, a wig maker who had premises on the close from 1712. The buildings on the close are some of the oldest surviving in the town. The excellent Halliwell's House Museum has a number of exhibits that tell the story of Selkirk's fascinating history.

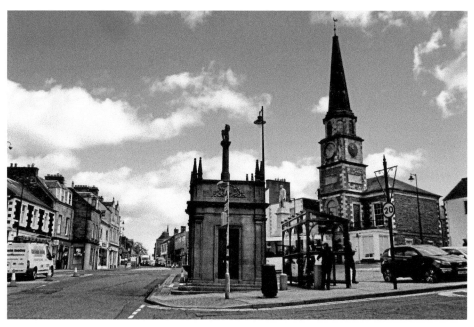

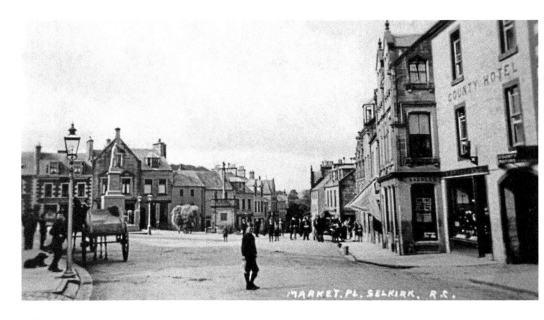

Selkirk Market Place IV

'Selkirk has a weekly market every Tuesday. It has six annual fairs, which are held on the following days, viz. First, held on first Wednesday of March at which is sold seed-oats and heavy ewes; Second, 25th of March, for hiring servants; Third, 4th of July; Fourth, 10th of August, a cattle and horse market; Fifth, 20th of October for hiring winter servants; Sixth, 8th of December, for selling meal.' (Robert Forsyth, *The Beauties of Scotland*, 1805)

Two early views of Market Place from the High Street. The importance of Selkirk as an agricultural centre is clear from the cartload of hay trundling through Market Place, the two cows being herded towards the High Street and the saddler's shop in the right foreground. Immediately behind the Sir Walter Scott statue is the Alexandra Temperance Hotel.

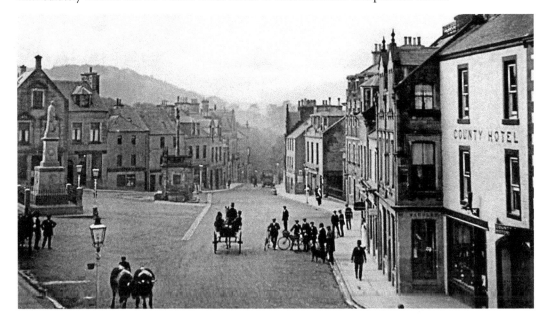

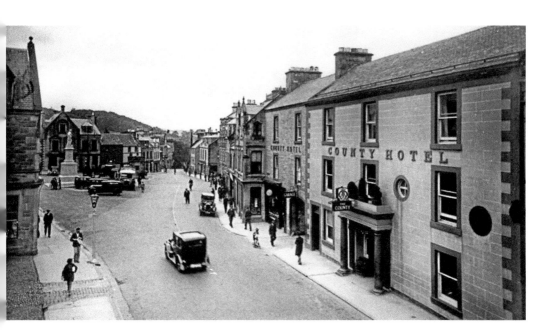

Selkirk Market Place V

The evolution and increasing importance of motor transport is clear in these two images of Market Place from the High Street. The County Hotel is shown as the Grapes Inn on an 1823 plan of Selkirk. It was a former coaching inn that had stabling in a courtyard to the rear of the building. It was frequented by Sir Walter Scott and was the meeting place of the Forest Club. The present building dates from the early nineteenth century and incorporates earlier fabric.

The life-sized statue of a dog over the entrance of the County Hotel depicts Red Dog Souter, a famous local greyhound owned by a former hotel proprietor. A plaque at the entrance to the hotel commemorates the visit in December 1856 of the Hungarian political leader Louis Kossuth (1802–94).

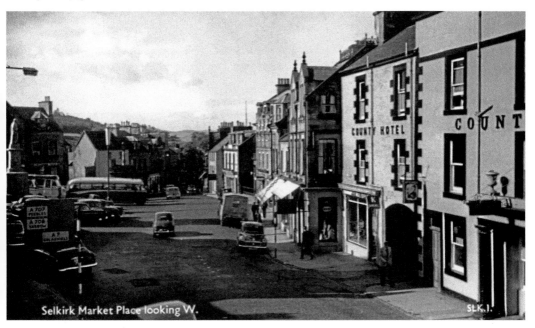

Selkirk Market Place looking W.

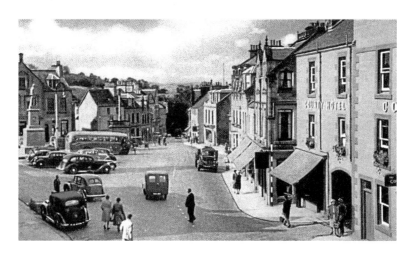

Selkirk Market Place VI

> 'As for Selkirk town, its appearance is truly deplorable. The houses are mostly old, falling to pieces, and deserted: nothing but dirt and misery to be seen. I had not breakfasted, therefore entered the inn; I was totally unprovided with necessaries for that meal. Every being, and thing in the house, disgusted me at first sight; the extreme dirt, and the smell of the whole, was nauseating in the highest degree.' (The Hon. Mrs Sarah Murray, *A Companion and Useful Guide to the Beauties Scotland*, 1805)

The Hon. Mrs Murray took a rather dim view of Selkirk when she visited in 1805 during a journey around Scotland. The Souters seemed to have taken note and the nineteenth century was a period of significant improvement to the town: fine new buildings were erected, streets were paved and the old Tolbooth, which stood in the middle of Market Place, was demolished.

By the 1880s, the *Ordnance Gazetteer of Scotland* was able to provide the following more favourable report: 'At the beginning of the present century Selkirk presented the appearance of an ill built, irregular, and decaying place, fast hastening to extinction; but since then it has suddenly revived, has undergone both renovation and extension, and is now a pleasant, prosperous, and comparatively ornate place, including various lines of new thoroughfares, elegant private residences, several good public buildings, and a number of busy factories.'

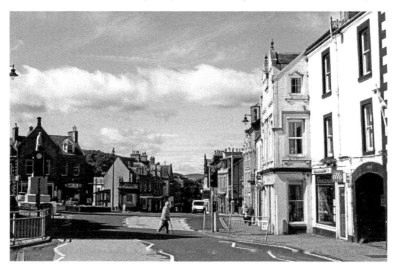

West Port, Selkirk

Views of West Port from Market Place. West Port was the site of the gate that guarded the western approach to the town. It was demolished in 1771. A plaque on the building at No. 3 West Port (to the left of the images) is inscribed: 'In a house on or near this site James Graham Marquis of Montrose spent the night before the battle at Philiphaugh on 13th September 1645 – "A Candidate for Immortality", Wishart, erected by Selkirk Merchant Company'.

The Town Arms Inn on the West Port was constructed as a public meeting hall in 1876 and the frontage includes the coats of arms of Selkirk above the door. The hall was converted to a public house in 1905.

The building at No. 3 Market Place (Taste of Spice at the time of writing) dates from 1815 and is shown as a Masonic lodge on Wood's 1823 plan of Selkirk – the foundation stone was laid by Sir Walter Scott. The Masonic lodge moved to Back Row in 1897. It has been suggested that this was the site of Selkirk's first café, which was used by French Napoleonic prisoners of war who were billeted in the town. When the adjacent bank building was built around 1860 for the British Linen Company Bank, it was set back from the building line and a column was needed to support the corner of No. 3 Market Place.

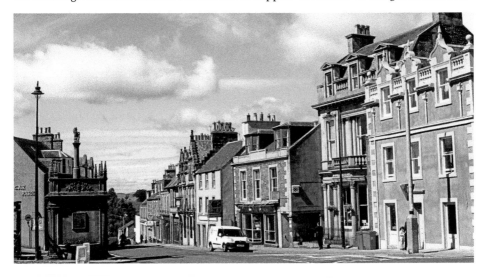

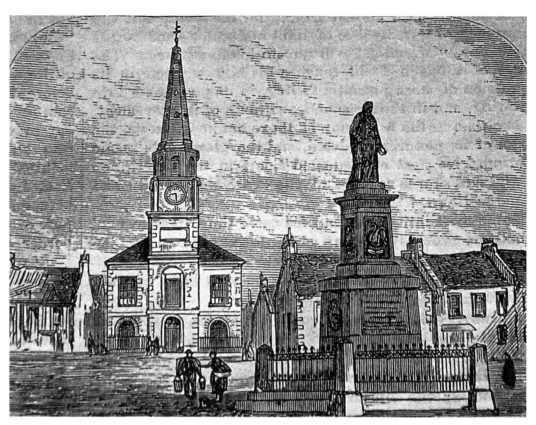

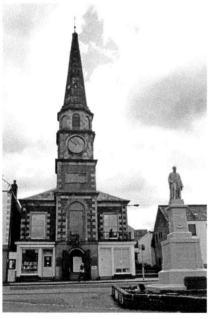

Town House, Old Sheriff Court, Market Place, Selkirk
The Town House dates from 1803 and replaced an earlier tolbooth, which was demolished in 1801. With its 30.5-metre- (110-feet-) high steeple, it is a landmark feature on Market Place. It originally contained a jail, the court and a library. Sir Walter Scott, as sheriff-depute of Selkirk, dispensed justice from the building. The Sheriff Court moved out in the 1870s, and the building was used as the Town Hall until the 1970s. It is now a museum that features Scott's literary and legal life.

A plaque to one side of the main entrance door commemorates the granting of a charter to Selkirk by James V on 4 March 1535, which renewed earlier lost charters – it was unveiled on 14 June 1935 by the Earl of Home. The plaque on the other side of the main entrance door commemorates Sir Walter Scott's service as sheriff of Selkirk between 1803 and 1832.

The original 1757 burgh bell is still rung every evening at 8 p.m. as a curfew bell, an ancient custom that dates back to medieval times and was intended to remind Souters to dampen down their fires as a precaution against conflagrations, at a time when most buildings were constructed of timber with thatched roofs.

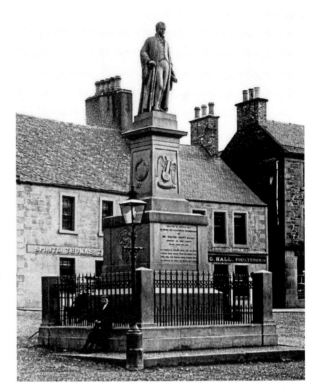

Sir Walter Scott Memorial, Market Place, Selkirk

The statue of Sir Walter Scott in Market Place stands outside the former courtroom and Town House in the centre of Selkirk. It commemorates Scott's long association with Selkirk. The statue depicts Scott in his role as the sheriff (the *shirra*). It is the work of Alexander Handyside Ritchie and was unveiled by the Duke of Buccleuch in 1839. The pedestal includes the heraldic emblem of Scott, the arms of Selkirk, a winged harp and a Scots thistle. The site of Selkirk's long-lost mercat cross is marked by a pattern of cobbles beside the statue.

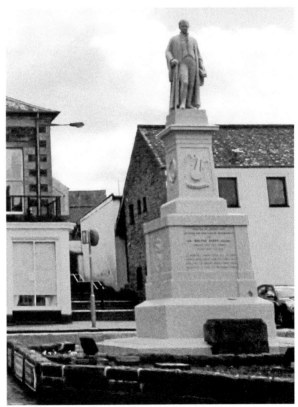

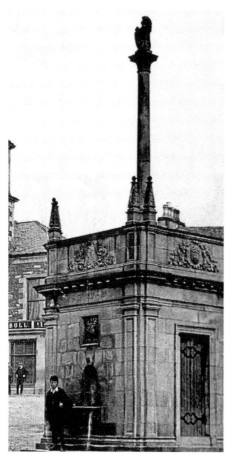

The Pant Well, Market Place, Selkirk

Selkirk's original Pant Well was built in 1706 to provide a supply of water for the town. It takes its name from the granite overflow trough (pant), which provided a drinking supply for animals and was added in 1715.

The current ornamental well house was built in 1898 to commemorate Queen Victoria's Jubilee. It includes Selkirk's coat of arms, a heraldic shield from the original well, a lion-headed tap, an image of Queen Victoria and a bronze plaque commemorating members of the Selkirk Detachment Border Rifles who fought in the Boer War.

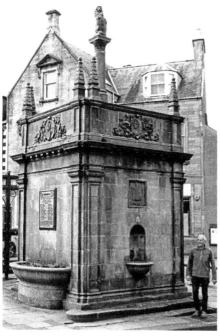

The Selkirk Bannock

'Before quitting Selkirk, it
ought to be mentioned, that it is
famous for the manufacture of
a peculiarly light and agreeable
species of bread, called Selkirk
Bannocks.' (Robert Chambers,
The Picture of Scotland, 1827)

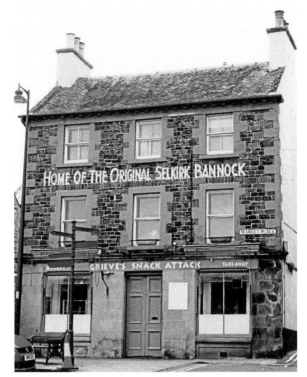

Selkirk is famed as the home of the
bannock, which takes its name from
the town. The building at No. 33
Market Place, which dates from
around 1820, displays a prominent
sign claiming it is 'Home of The
Original Selkirk Bannock'. The
Selkirk Bannock is said to have been
invented by a baker, Robert Douglas,
who opened a shop in Selkirk
in 1859.

In Scotland, breads were
traditionally baked on a bannock
stone or girdle (griddle) rather than
an oven, which meant that they were
unleavened and circular – the name
bannock is derived from the Latin
panicium, 'baked dough'. Over time
these bannocks were made with
wheat flour, yeast and were enriched
with butter and dried fruit – like the
Selkirk Bannock.

The Selkirk Bannock is mentioned in
Sir Walter Scott's *Bride of Lammermoor*
and Queen Victoria on a visit to
Abbotsford is said to have taken her
tea with a slice of Selkirk Bannock. The
tradition of locally produced Selkirk
Bannocks is continued by Alexander
Dalgetty & Sons, who claim to have the
only surviving genuine recipe for the
Selkirk Bannock. Alex Dalgetty worked
in Selkirk at the bakery that produced
the original bannock, but left to set up
his own business in Galashiels.

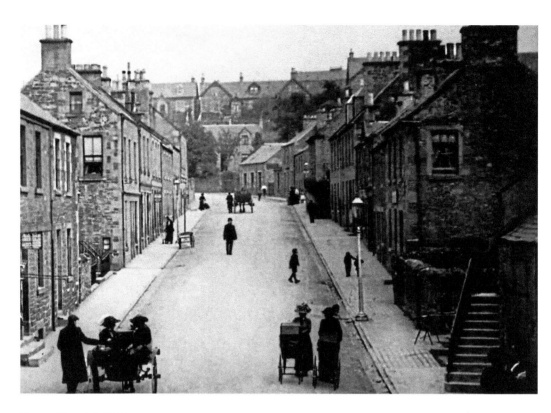

Tower Street Selkirk

Tower Street is shown as a New Road with only sparse development on Wood's 1823 plan of Selkirk. However, it was built up rapidly and a plan of 1865 shows it fully developed. It is now a busy thoroughfare linking Selkirk with the A7 south to Hawick. It would be a little dangerous to be pushing a pram in the middle of the road now. The buildings on the right of the older image were replaced by new flats in the 1960s.

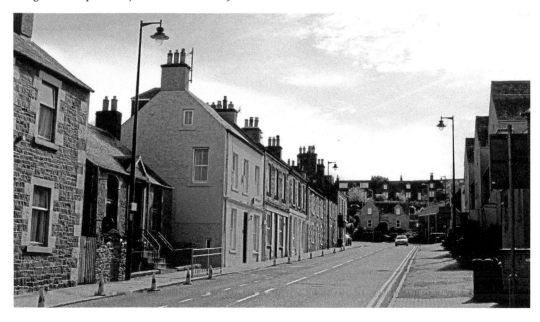

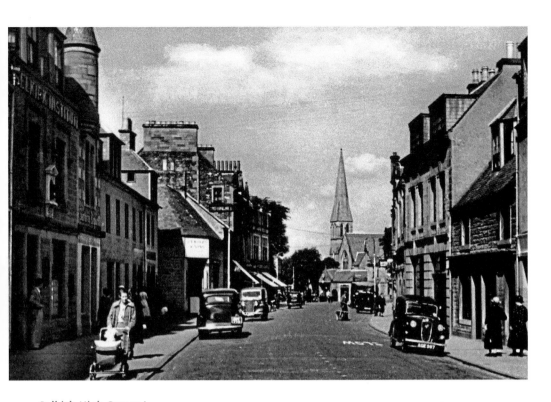

Selkirk High Street I

These are two relatively unchanged views looking east on Selkirk High Street towards the spire of the parish church. The opening service of the church took place on 16 September 1880 and the spire is a local landmark. The church was built on the site of an earlier dovecot.

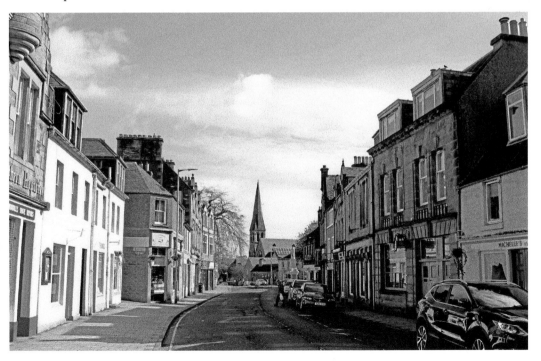

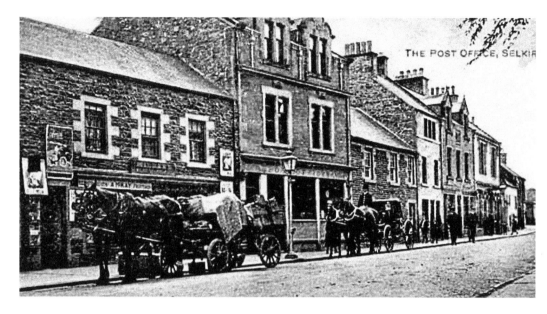

THE POST OFFICE, SELKIRK

Selkirk High Street II

The red sandstone building in the newer image dates from the late nineteenth century and was a branch of the Savings Bank. It replaced the two-storey building in the older image. The words 'Savings Bank', which were inscribed on the frontage, are now covered with a modern fascia. The building with the lamp outside in the older image was Selkirk's post office at the time the image was taken.

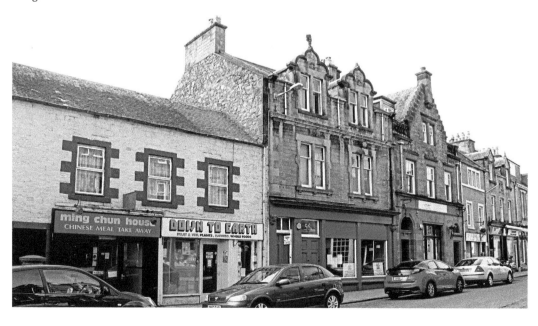

Selkirk High Street III

These two buildings on the High Street have a number of historical associations. The building on the left was the site in 1854 of the birthplace of Tom Scott (1854–1927), the eminent artist, which is commemorated by a plaque.

The Selkirk Institute opened in January 1911 and was immediately popular. At the first annual general meeting in the billiard room of the institute, with Revd A. Ross presiding, on 16 October 1911, it was noted that there was a healthy balance sheet and that the institute had fulfilled the purpose for which it was founded. There were 387 members and the enterprise was well patronised. There was some concern expressed at the meeting that the number of games of billiard played (7,426) far exceeded the number of baths taken (1,780). The opinion that the institute was a 'grand howff on a wet night' was met with applause. The behaviour of the members was considered exemplary and one lady, who had looked in, was quoted as remarking that the members were 'a company of gentlemen', which was met with further applause.

The building on the right was the original home of the *Selkirk Advertiser*, which was established by George Lewis in the 1850s. As the name implies, it contained mainly adverts and was distributed free in the town. In 1855 it became the *Southern Reporter*.

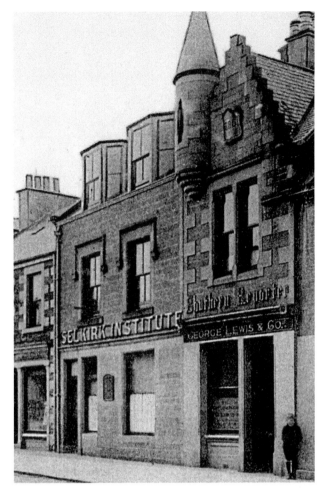

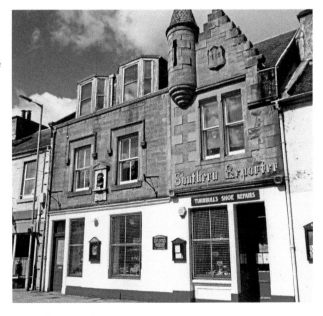

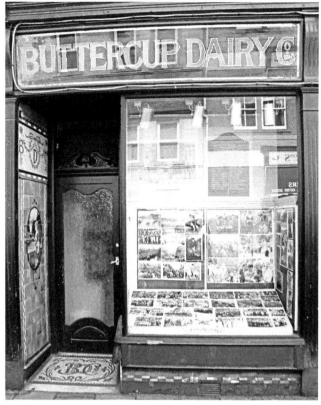

Selkirk High Street, the Buttercup Dairy

This shop on the High Street was the location of Selkirk's Buttercup Dairy. The distinctive tiled mural, which was the logo of the company, remains at the entrance. The mural shows a girl holding a buttercup under the chin of a large, sociable cow. The Buttercup Dairy Co. was founded by Andrew Ewing. Ewing opened a grocer's shop in Dundee in 1894 and the first Buttercup Dairy in Kirkcaldy in 1904. Within fifteen years it was one of the first chain stores with 250 branches. The shops were known for their cleanliness and all female staff in crisp white overalls. Ewing purchased Clermiston Mains, a large estate to the west of Edinburgh, and opened an enormous poultry farm, which accommodated 200,000 hens. Ewing was a great philanthropist and gave all the eggs laid on a Sunday to local charities. As was his wish, he died close to penniless in 1956, having spent a great part of his life supporting good causes.

The shop is on the ground floor of the building that was the former Swan/Black Swan Hotel – hence the carving of a swan on the upper floors. The hotel was where French prisoners of war were billeted during the Napoleonic Wars.

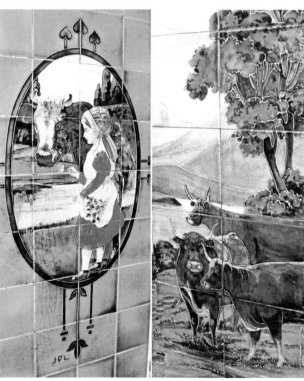

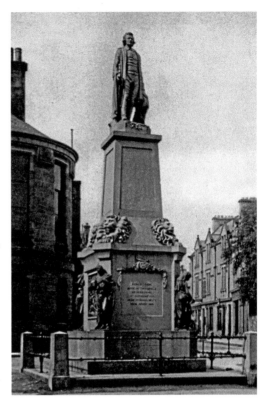

Selkirk, Mungo Park Memorial, High Street and Back Row

This memorial in Selkirk commemorates the life of Mungo Park, the renowned explorer of the Niger River. It was unveiled in March 1859 and was the work of talented local sculptor Andrew Currie, a 'kinsman' of Park, who had a workshop in Darnick. Park is shown 'standing in his ordinary dress with his well-known handsome, intrepid and modest face, and his well-knit frame' – he holds a sextant in his right hand and a scroll in his left.

The main inscription reads: 'MUNGO PARK/Born at Foulshiels Selkirkshire/10th September, 1771/Killed at Boussa on the Niger, Africa 1805'. The other two sides have carved inscriptions commemorating Park and his two Selkirk companions on his last fateful expedition to Africa: Alexander Anderson, his brother-in-law, George Scott, the expedition's artist, and his son Thomas Park, who died in West Africa in 1827 while 'endeavouring to obtain trace of his distinguished father'.

The statue stands opposite the house formerly occupied by Dr Anderson, Park's early employer and his father-in-law.

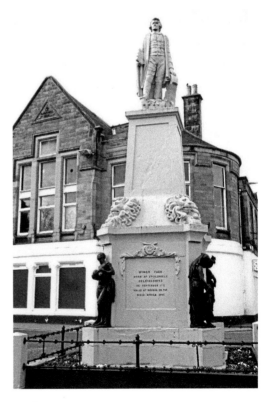

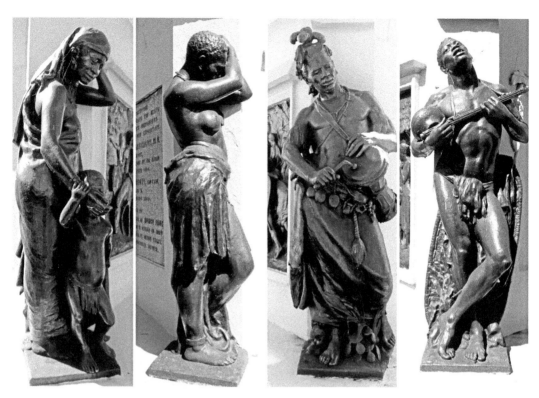

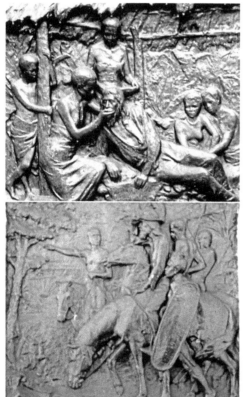

Mungo Park Memorial Details, Selkirk

The bronze bas relief panels on two sides of the statue depicting Mungo Park's travels were designed by Thomas Clapperton and were added in 1905. The bronze figurative statues of Africans on the corners were added in 1913. According to a contemporary report, Currie originally intended four bas relief panels, two of which would have shown Park with his friend Sir Walter Scott at Yarrow and on the 'heights of Miuchmoor'.

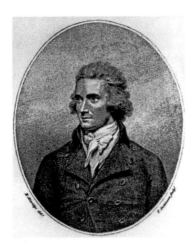

Mungo Park's Birthplace at Foulshiels

Mungo Park was born on 10 September 1771 at Foulshiels on the Yarrow Water, 4 miles from Selkirk, and is one of the town's most famous sons. A plaque on the ruins of the building where he was born reads: 'Mungo Park/Born 10th September 1771/Killed at Boussa on the Niger, Africa 1805'.

Park was the seventh in a family of thirteen of a tenant farmer and attended Selkirk grammar school. In 1785, he was apprenticed to Thomas Anderson, a surgeon in Selkirk, before completing his formal training in medicine at the University of Edinburgh in 1792. In 1793, he was appointed assistant surgeon on a voyage to Sumatra, where he made 'valuable observations and discoveries in botany, and other branches of natural history'.

Park, who had 'a general passion for travelling', then volunteered for an expedition to determine the rise and course of the Niger and he set sail from Portsmouth on 22 May 1795. It was a hazardous journey, but he found the River Niger and traced its route. He returned to Scotland on 22 December 1797, long after he had been given up for dead.

He returned to Foulshiels in June 1798 and spent time preparing his best-selling book *Travels in the Interior Districts of Africa*. He set up as a surgeon in Peebles in October 1800, but it was a life that he found monotonous after his African adventures. In January 1805 he set sail again for the Gambia on a government sponsored expedition. This was to prove fateful and Park was killed during a conflict with the local people in Boussa.

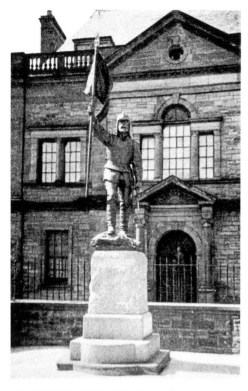

The Flodden Field Monument, Scott's Place, Selkirk

The statue commemorates the town's involvement with the Battle of Flodden. Tradition has it that a contingent of eighty men left Selkirk to fight in the ill-starred Battle of Flodden on 9 September 1513. 10,000 of James IV's men died, including the king and many of the nobility – the Flower of Scotland.

Fletcher, a weaver, was the only Selkirk man to survive the battle. He returned to the town with a captured bloodstained English flag, but was too exhausted and overcome with grief at the death of his friends to speak. To reflect his despair, he waved the flag above his head and cast it to the ground.

The bronze statue depicts a striding figure of Fletcher in armour clutching a sword in his left hand and holding a flag overhead with his right. It was sculpted by Galashiels-born Thomas Clapperton (1879–1962) and unveiled in 1913, the 400th anniversary of the battle, by the Earl of Rosebury. The brass plaque on the granite base is inscribed: 'This monument, embodying the spirit of the Selkirk tradition and erected to Commemorate the Four Hundredth anniversary of the battle of Flodden Field, was unveiled by the Earl of Rosebury, KG, KT. Andrew Lusk Allan Provost, 1913'.

The Casting of the Colours by the standard bearer at the Selkirk Common Riding celebrations commemorates Fletcher's return to Selkirk and the town's losses at the battle.

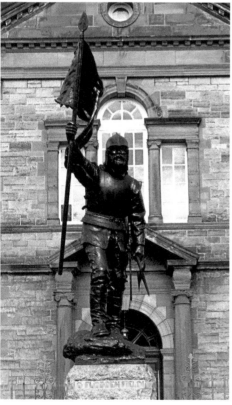

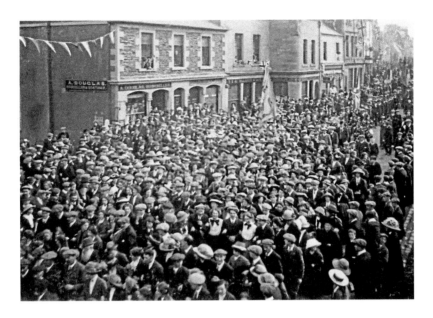

Selkirk Common Riding I

Common Ridings are an annual event in most of the Border towns. It is a tradition that dates back to the sixteenth century, when groups of mounted townsfolk would ride out to check that the boundaries of the town's common lands were secure. By the eighteenth century, the Riding of the Marches was no longer necessary. However, the spectacle evolved into a celebration of the traditions of the towns.

Selkirk adopts a festive mood for the Common Riding weekend in June and there are numerous elaborate ceremonial events. Hundreds of riders are involved in the Riding of the Marches and almost the entire town turns out, to either take part in or to watch the procession when it leaves the Back Row early in the morning. Crowds line the waterside to wish the riders 'Safe Oot and Safe In', as they cross the Ettrick Water. There are also fun fairs, balls, bands and community singing.

The images show a large crowd at the 1913 Selkirk Common Riding and a handbill from 1908, with a song that celebrates the event and the 'Flooers o' the Forest'. John Roberts was the provost and George Mitchell the standard bearer.

PROVOST

STANDARD-BEARER

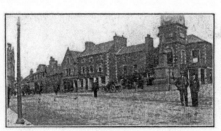

JOHN ROBERTS.

MARKET PLACE.

GEORGE MITCHELL.

 SELKIRK COMMON-RIDING, 1908.

When the warl' is green an' bonnie in the glorious month o' June,
Then my heart grows warm wi' longing for oor dear auld Selkirk toon ;
An' wad gang oot wi' the Souters wha are settin' oot tae ride
The mairches o' the heritage for which their faithers died.

Peace noo lulls us wi' its soothin', but in days when War gleamed red
Owre oor Borderland, the Souters in the battle ever led ;
An' as we look owre oor Common, say we o' oor guid auld toon,
"Wha wad ken o' Selkirk valour let him only look aroun'."

Hear the liltin' o' the maidens, hear the music o' the band,
Ettrick thrills beneath the echoes as it sweeps adoon the land ;
See wi' hearts that tingle strangely, oor braw colours cast again,
As brave Fletcher, hame frae Flodden, cast them in his pride and pain.

Dear auld toon, sae wreathed wi' glory ! oor hearts gang tae ye to-day,
For the Flooers o' the Forest, they are no a' wede away ;
An' ilk Souter heart is turning to the hame whaur it was born,
An' is joining in oor singin' on this Common-Riding Morn.

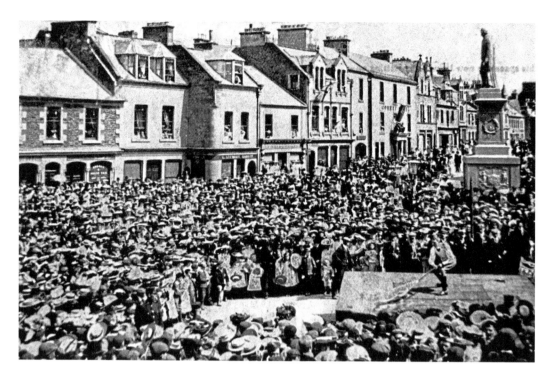

Selkirk Common Riding II

The ceremony of the Casting of the Colours takes place in Market Place. The royal burgh standard bearer and standard bearers from Selkirk's six guilds 'cast' their flags to the tune 'Up Wi' The Souters o' Selkirk'. This commemorates the town's link to the Battle of Flodden and the return of Fletcher, the sole survivor of the contingent of men that left from Selkirk for the battle.

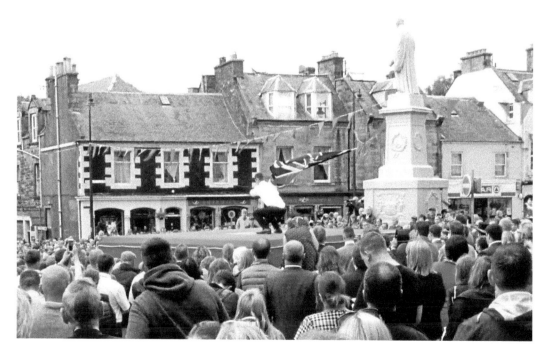

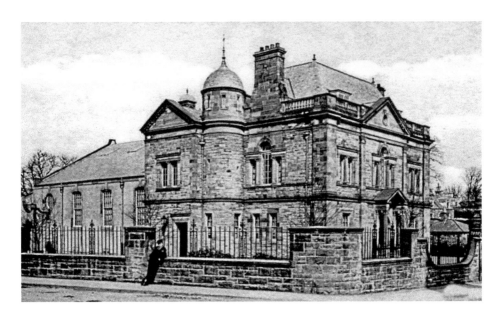

Victoria Hall

The foundation stone of the fine red sandstone Victoria Hall was laid in 1895. It was designed by Hippoltye J. Blanc and completed in 1897 – Queen Victoria's Diamond Jubilee year. The Fletcher Memorial stands in front of the hall and on the corner there is a memorial to local poet James Brown (1832–1904). It includes a quote from his poem 'Selkirk after Flodden': 'Then I turn to my sister Jean, and my arms about her twine.' Brown was better known as J. B. Selkirk. His family was involved in the textile industry in Selkirk and built the Ettrick Mills. One of his most popular poems was 'Auld Selkirk Toun': 'Auld Selkirk, Auld Selkirk, She's ancient but she's braw, 'Mang a' the bonnie Border touns, The fairest o' them aw.'

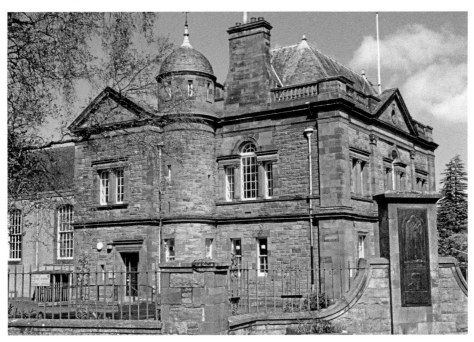

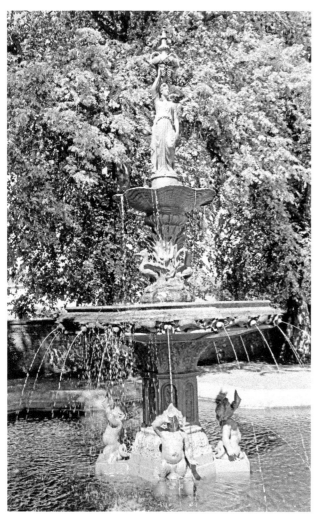

Victoria Hall, Fountain

The grand fountain in the grounds of the Victoria Hall was originally located at Philiphaugh House. It was donated to Selkirk and re-erected at the Victoria Hall. The Philiphaugh House estate was the ancestral home of the Murray family – twenty-one consecutive generations lived in the house, making it the longest continuous occupation of a house by one family in Scotland.

In 1890, the house was purchased by the Strang family and the existing mansion was extensively renovated and enlarged by Edinburgh architect James Maitland Wardrop. The huge conservatory was one of the outstanding features of the new house. Conservatories were a fashionable feature of many large Victorian houses at a time when the size of the conservatory and the rarity of its plants reflected a degree of social standing.

The mansion was demolished in the 1960s following a fire and was replaced by a new smaller building.

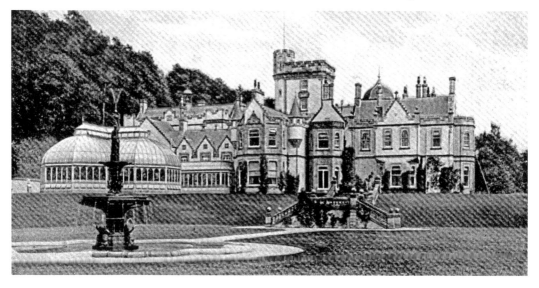

Selkirk War Memorial

The Selkirk war memorial stands on a prominent site at the intersection of Ettrick Terrace and Chapel Place on the main road leading into the town from Edinburgh. It is a particularly fine monument with a 9-metre- (30-feet-) high column surmounted by a Maltese cross and incorporating a bronze figure of Victory.

The names of the 292 local men who fell in the First Word War are inscribed on two bronze memorial panels and a central bronze panel lists the Second World War casualties. A total of 1,296 names are recorded in Selkirk's First World War Roll of Honour. It is inscribed 'To the Glory of God and in honoured memory of the men of the Burgh and Parish of Selkirk who fell in the Great War, 1914-19'. The memorial was designed by the architect Sir Robert Lorimer and the bronze statue was by Thomas J. Clapperton.

The war memorial was unveiled on 3 December 1921 in the presence of many town dignitaries and 'an expectant throng' of local people. In his address, Robert Munro, Secretary of State for Scotland and the local Member of Parliament, noted that it was a fitting tribute to the gallantry of the men of the Borders who had nobly sacrificed their lives in defence of their country and referred to the qualities of chivalry and courage, which they had inherited from their forefathers.

At the conclusion of Mr Munro's address, Mrs Smith, the wife of the sheriff, unveiled the bronze figure of Victory. There was a two minutes' silence, the last post was sounded and the band played 'The Flowers of the Forest'.

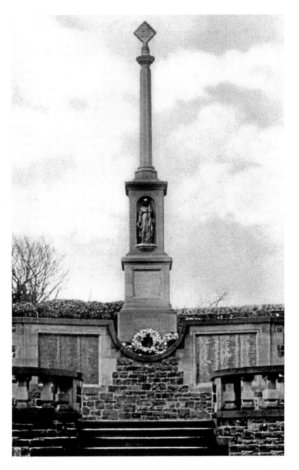

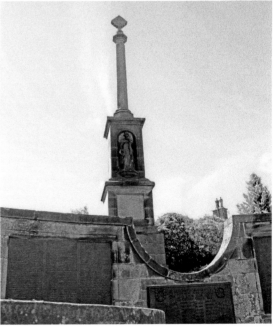

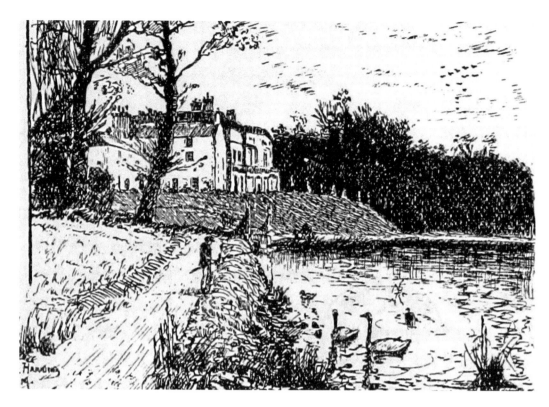

The Haining, Selkirk I

'There is hard by the toune on the southwest part thereof one gentleman's house called Haining belonging to one of the name of Pringle. There stands ane ancientt house with ane other new building upon the north side of the Loch. The house stands very pleasant with its orchards, avenues, parks and planting and pigeon house.' (Walter Macfarlane, *Geographical Collections Relating to Scotland*, 1748)

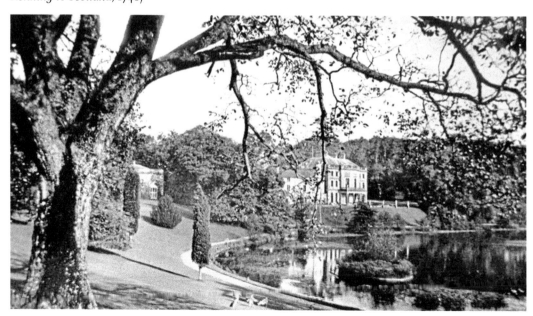

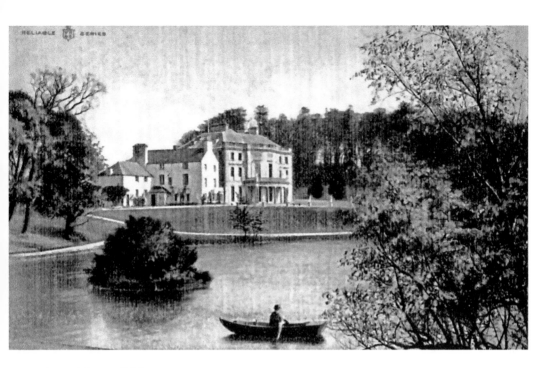

The Haining, Selkirk II

The Haining estate was owned by the Scott family in the late fifteenth and sixteenth centuries, and then the Riddells in the seventeenth century. In 1701, John Pringle purchased the estate, which commenced its long association with the Pringle and Pringle-Pattison family. Subsequent members of the family initiated most of the changes to the buildings and landscape.

The present classical villa at the Haining was commissioned by Mark Pringle and dates from around 1795. It replaced an earlier building, which was used as accommodation for servants, until it burnt down in 1944. The house was used by the military during the Second World War. In 2009, the estate was left 'for the benefit of the community of Selkirkshire and the wider public'.

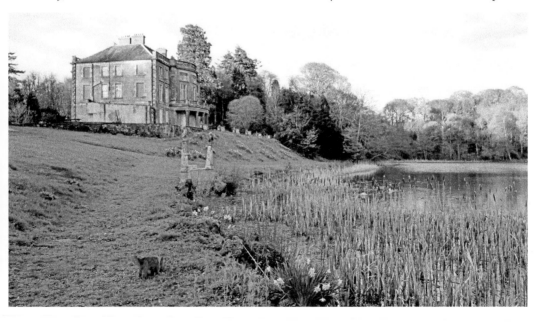

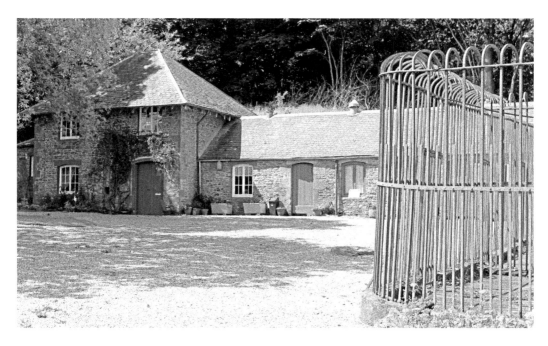

Haining Stables

The stables at the Haining were designed by John Smith in 1818–19. The bowed southern block was converted for housing in 1983. The stables courtyard is accessed through a central arch in the northern block. The keystone over the arch features a carved horse skull, which is reputed to represent the horse that resulted in the death of John Pringle in 1831.

The Dairy Cottage to the west of the stables date from the mid-nineteenth century. The cages close to the stables were used to house wild animals, including wolves and bears, which attracted curious visitors from the town.

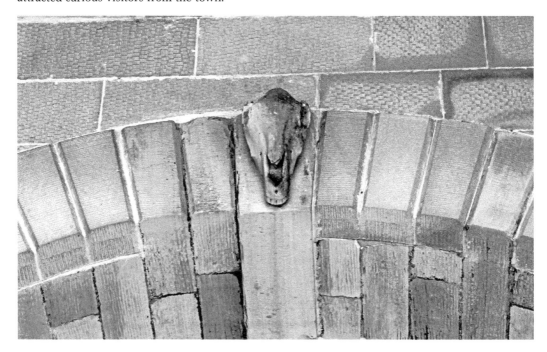

Selkirk Castle

Peel Hill, the large prominent flat-topped mound, immediately to the north-east of the Haining between the south end of Castle Street and Haining Loch, is all that remains of Selkirk Castle, which would have dominated the medieval landscape of Selkirk. The castle was constructed before AD 1119 – it is mentioned in the charter that established Selkirk Abbey, which dates to around that year.

It was originally a motte-and-bailey castle built from earth and timber. It was rebuilt and strengthened with a fortified keep (pele) after it was captured by the English in 1301. It was retaken by the Scots in 1302 and was again in English hands in 1311, when Edward II invaded Scotland. There is no record of the castle after 1333 and it is assumed that it was destroyed at some stage during the Wars of Independence.

41

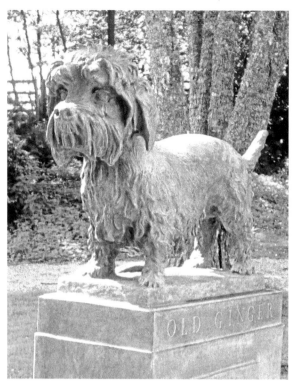

The Haining and the Dandie Dinmont

The bronze statue at the Haining commemorates Old Ginger, the Dandie Dinmot Terrier, which is considered to be the father of the breed – the first Dandie to have a known sire and dam. It was unveiled on 4 June 2017 beside the kennels where Old Ginger was born on the same date in 1842. The unveiling ceremony was preceded by a parade of Dandie Dinmonts through Selkirk.

The breed takes its name from a character in Sir Walter Scott's 1815 novel *Guy Mannering* and it is the only breed named after a fictional character. A Dandie Dinmont Discovery Centre has also been opened at the Haining stables and there is a plaque at the Fleece Hotel to commemorate the foundation of the Dandie Dinmont Terrier Club at the hotel on 17 November 1875.

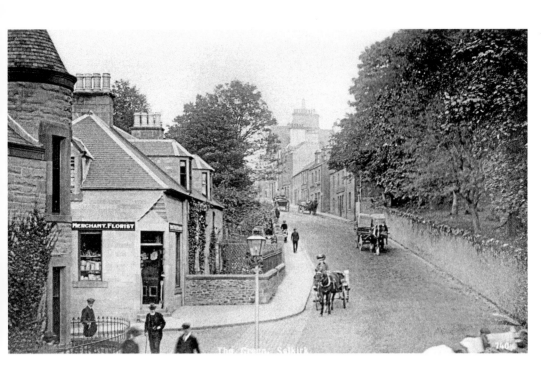

The Green, Selkirk

These views are looking towards the West Port on The Green. The importance of horse transport is reflected in the older image – with a heavily loaded cart and a sporty-looking gig driven by a bonneted lady heading down the hill.

The single-storey building on the left with the splayed corner was a florist shop for many years and is now a private house. The boundary wall of the Haining is to the right of the images. The impressive north gate (town gate) to the Haining is just out of view of the images. The gate was designed by John Smith and dates from around 1825.

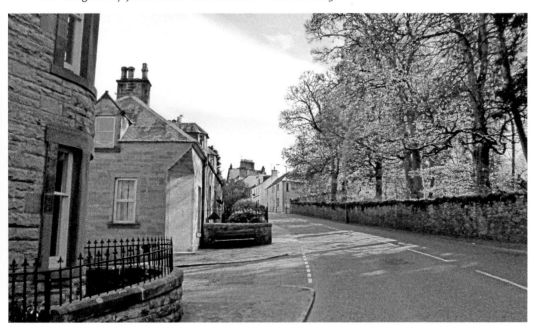

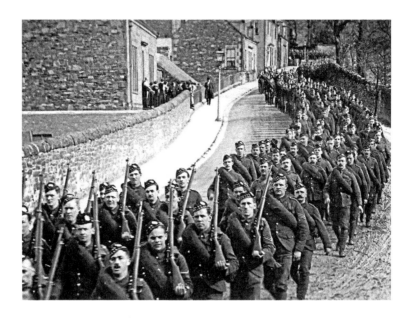

The Royal Scots, The Green, Selkirk

'On Wednesday morning the 1/6th Battalion Royal Scots, which had been billeted in Selkirk for just over two months, left the town for Peebles. During the time they have maintained a most happy relationship with the civilian community, and there were many sad hearts when the time came to say farewell. They were marshalled at the Victoria Hall and marched via the Green to the station. All along the route people had assembled to wave them goodbye. There were cheers and counter-cheers, and once or twice the soldiers were heard to shout, "Good Old Selkirk".

At the station a great crowd assembled, including Provost Allan and other prominent townsfolk. The general public were allowed on the platform and then was witnessed a scene that perhaps has never been seen in Selkirk. During the time they have been in Selkirk many of the 1/6th Royal Scots have learned to love the mill girls, and when it came to saying goodbye there was no suppressing their feelings. There was universal hand-shaking, quite a lot of kissing, and also a few tears. Selkirk will aye remember the visit of the 'First Sixth', and will watch anxiously how they fare when they are ordered abroad for active service.' (*Southern Reporter*, 13 May 1915)

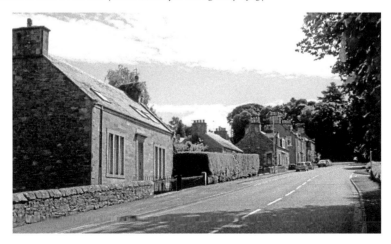

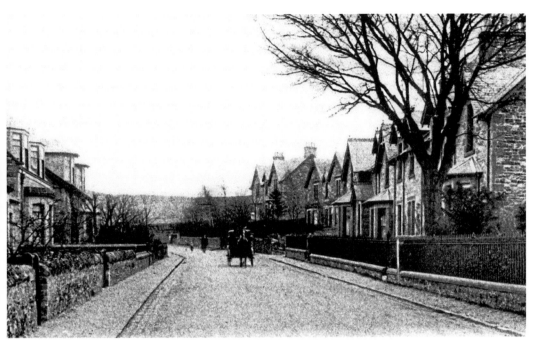

Hillside Terrace, Selkirk

The enduring nature of parts of Selkirk is reflected in these remarkably unchanged views of the substantial residential properties on Hillside Terrace, to the south of the town.

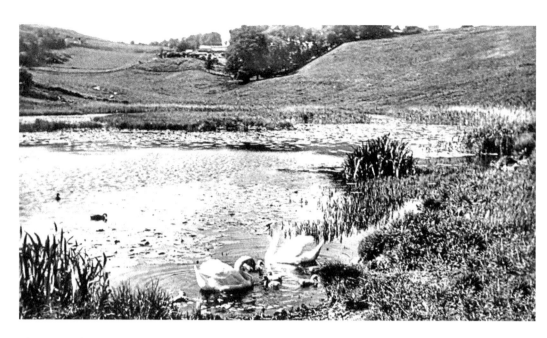

The Pot Loch, Selkirk

'In 1811, when the accumulation of French prisoners of war in England had become very great, it was decided to distribute them throughout Scotland. To Selkirk, as its share, came 190 men. In their dealings with the French officers, who were quartered in the town from 1811 to 1814, the Selkirk people displayed an admirable generosity and a gratifying amount of good feeling,

The Pot Loch is a small and once very deep lochan, or pond, nestling in a hollow at the foot of the pleasant heathery hills on which is now the Selkirk Golf Course. It was here that tradition told us the French prisoners went to catch frogs. That Frenchmen in their own land lived chiefly on a diet of frogs was the firm belief of a majority of the town's inhabitants, and that the prisoners went to the Pot Loch for any other purpose than to obtain supplies of what seemed to the townsfolk to be a very loathsome dainty, would never occur to them. The fact that the edible frog did not exist there, would make no difference in their belief.' (Andrew Lang, *Highways and Byways in the Borders*, 1913)

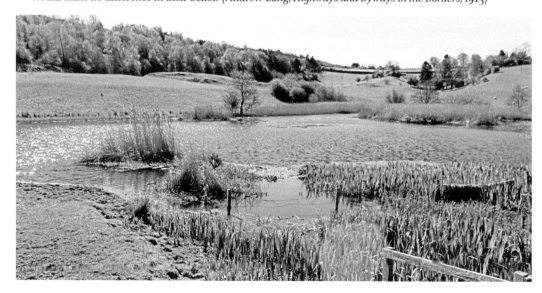

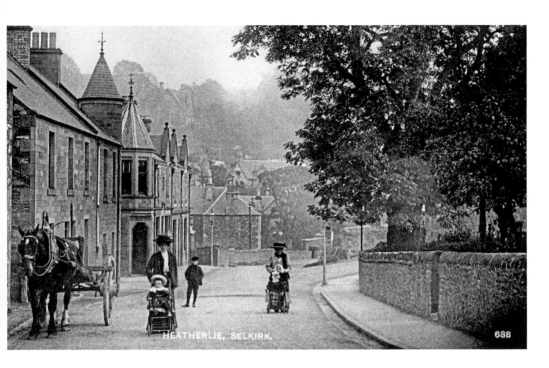

Heatherlie Terrrace, Selkirk

Heatherlie is shown as a place name to the west of Selkirk on nineteenth-century maps. The street links Yarrow Terrace to The Green. Except for the addition of a satellite dish, the buildings on the left are relatively unchanged. The children out for a stroll in their baby carriages with their mothers, or perhaps nannies, must have been from fairly affluent families.

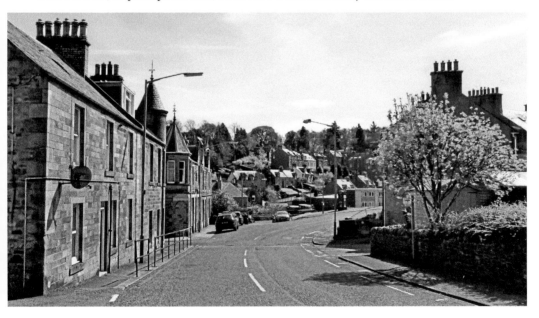

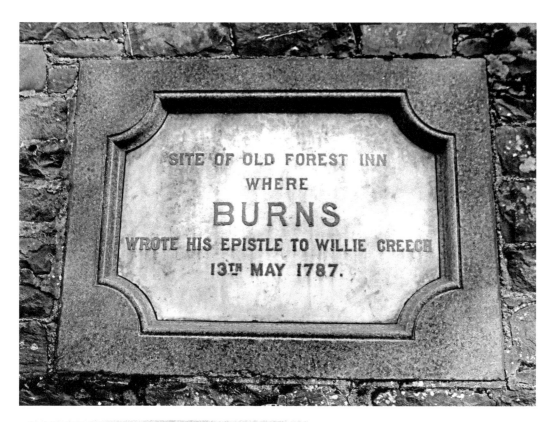

Burns Plaque, Selkirk

The plaque on a section of old wall on West Port was erected in 1884 and commemorates the visit by Robert Burns to Selkirk on 13 May 1787. He had lodgings at the Forest Inn and is believed to have written his *Epistle to Willie Creech* during his stay – it seems it was a wet night. The inn was demolished in 1878 for road widening. There is a local superstition that touching the plaque brings good luck. Apart from its name, Burns's *Selkirk Grace* has no direct link to the town. Burns recited it at a dinner given by the Earl of Selkirk at St Mary's Isle Priory, Galloway.

Souter Statue, Back Row, Selkirk

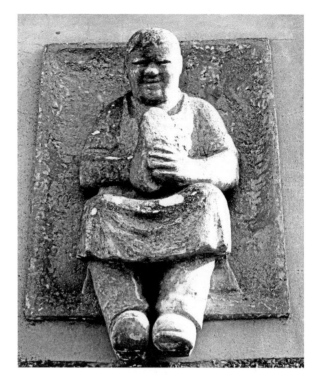

'Up wi' the Souters o' Selkirk.'
'In former times a principal
employment of the inhabitants
(of Selkirk) was the making
of single-soled shoon, a sort of
brogues with a single thin sole.
So prominent was this craft as
to give the name of 'Souters'
(shoemakers) to the whole
body of burgesses; while, in
conferring the freedom of the
burgh, one of the indispensable
ceremonies consisted in the
new-made burgess dipping
in his wine and then passing
through his mouth in token
of respect to the Souters
four or five bristles, such as
shoemakers use.' (*Ordnance
Gazetteer of Scotland*
F.H. Groome, 1882–84)

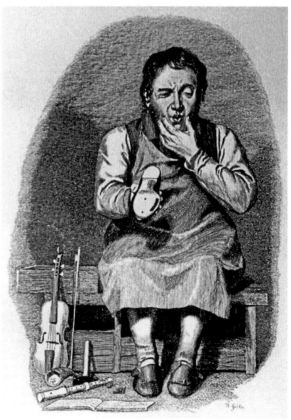

The small statue of a Souter
(shoemaker) on a house wall at
the southern end of Back Row
commemorates Selkirk's historical
associations with the trade.
Shoemaking was Selkirk's main
source of employment before the
arrival of the textile industry. The
Shoemakers' Guild was founded
in 1609 and only disbanded in the
1960s. And, of course, the name is
also used as a term for a native of
the town. Souters had a reputation
as being sociable and perhaps fond
of a drink. This certainly is the case
in the etching of a Souter examining
a shoe while whistling a tune with
his fiddle at the ready.
This part of Selkirk, which was
one of the most historic in the town,
was redeveloped in the 1960s.

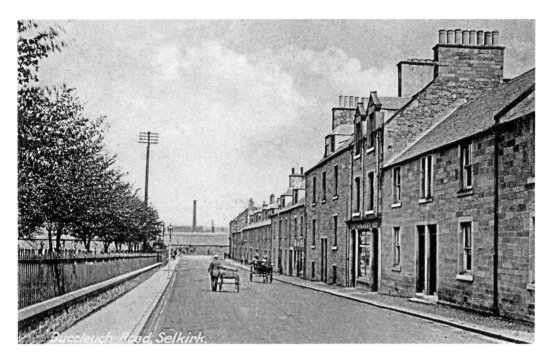

Buccleuch Road, Selkirk

Two views on Buccleuch Road looking towards Station Road with the chimney of the Forest Woollen Mill in the background of the older image. The railings on the left are on the boundary of Victoria Park. Selkirk railway station was to the left at the end of Buccleuch Road. The station opened in 1856, was closed to passengers in 1951 and closed completely in 1964. It was originally built in open fields, but by the 1900s was surrounded by textile mills, which were able to take advantage of the rail link.

A plaque at the end of Buccleuch Road commemorates the murder of John Muthag and Bailie James Kein by the Kers of Bridgeheugh on 25 July 1541 on their way to Edinburgh to settle a boundary dispute. John Muthag was elected in 1540 as Selkirk's first civic head to take the title provost.

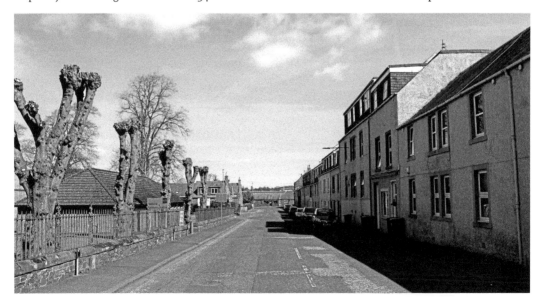

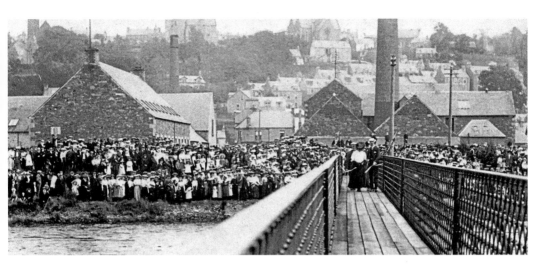

Bridge Opening, Selkirk

A huge crowd, dressed in their Sunday best, has turned out for the opening of the footbridge at Selkirk by local GP Dr Robet Meiikle and his wife on 16 August 1906. Dr Meikle was chairman of the Bazaar Committee and a trustee of the subscription fund; the bridge was financed by public subscription and a number of fundraising events. In December 1903, a three-day bazaar was held in the Victoria Hall to raise funds.

> 'The interior of the hall was fitted out to represent a scene at the Delhi Durbar. The scenic decorations were so arranged as to give the idea of a street square; and the arrangement of representations of balconies and mosques completed the idea of an Indian street market. The whole appearance was very picturesque and the various stalls were abundantly filled with beautiful articles.' (*Southern Reporter*, 17 December 1903)

A previous wooden bridge, which had been erected in 1872 by Sir John Murray of Philiphaugh, was swept away by an ice-flood in 1881. Another wooden bridge was erected but the southern section of this was lost in a 'gey fashious' flood at the end of 1901. The original bridge was replaced in 2015 as part of the Selkirk Flood Protection Scheme.

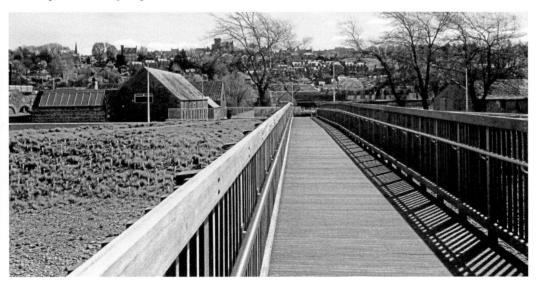

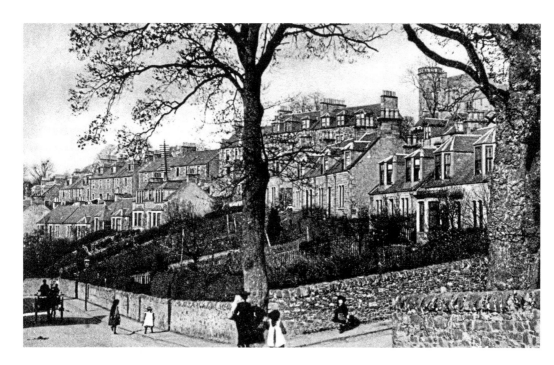

Mill Street, Selkirk

This area is shown as an open space, known as the Glebe, on nineteenth-century plans of Selkirk. It was attached to a manse with access from The Green. On Wood's 1823 plan of Selkirk the manse is shown as being occupied by the Revd J. Campbell. A glebe is a piece of land set aside for the minister.

Mill Street, or Mills Road as it was previously known, was the main access route to the Forest Mill and the town gasometer. The round tower of the County Buildings is in the background of the earlier image.

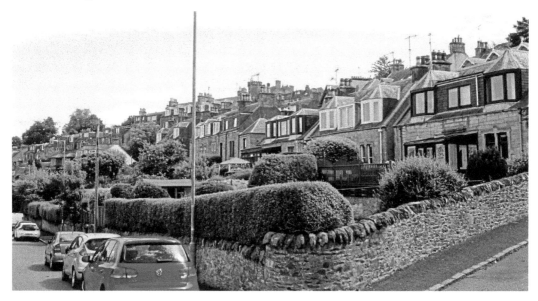

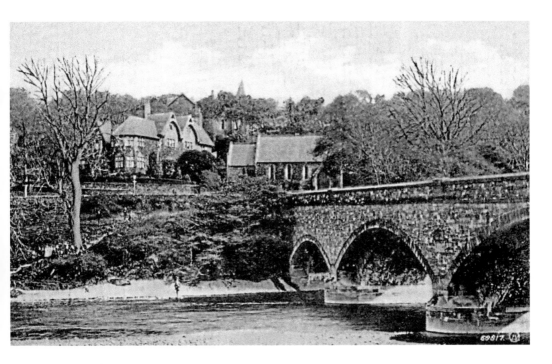

Selkirk Bridge

The old stone bridge at Selkirk, dated from 1771, was widened in 1881 and was swept away by floods in 1997. The new twin span concrete bridge dates from 1981 and carries the A701 over the Ettrick Water.

The substantial property on the opposite bank of the river dates from the mid-nineteenth century and was built as the parsonage for the former Episcopalian church to the west. It was a family home called Mauldsheugh at the time of the earlier image and became the Glen Hotel in the mid-1960s.

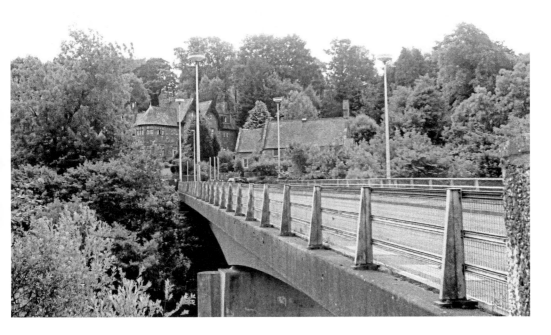

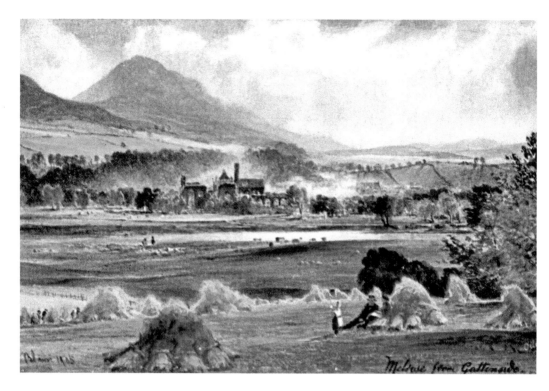

Melrose from Gattonside

'The ancient little town of Melrose occupies a situation of great beauty, on the northern base of the Eildon Hills, near the river Tweed. Its neighbourhood is thickly studded with villages, villas, and rural cottages, many of which are delightfully embowered amid orchards of fruit-trees, the highly cultivated condition of which gives to the Vale of Melrose, when viewed from the neighbouring heights, the appearance of one extensive garden. It partakes abundantly of these finest features of natural scenery, wood and water, hill and dale, in all their best and most beautiful varieties, so completely diversified with every description of romantic form, as to afford material for the delightful studies of the landscape painter almost inexhaustible.' (*Melrose and Its Vicinity*, 1841)

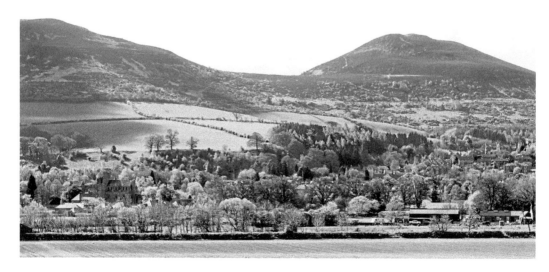

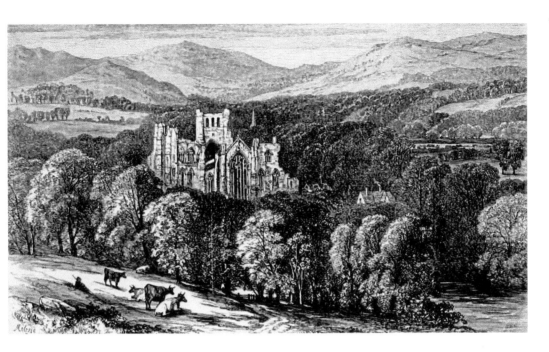

St Mary's Abbey, Melrose I

'The grace and ornament of Melrose in particular, is its magnificent Abbey, which, from the beauty of its architecture, the harmony of its parts, and the extent of its remains, must be regarded as one of the greatest objects of interest which this country can boast. By singular good fortune, Melrose Abbey is one of the most entire, as it is unquestionably the finest, specimen of Gothic architecture and sculpture in Scotland, and in its general aspect is as elegant, as in its minute details it is unique.' (John Rutherfurd, *Rutherfurd's Guide*, 1850)

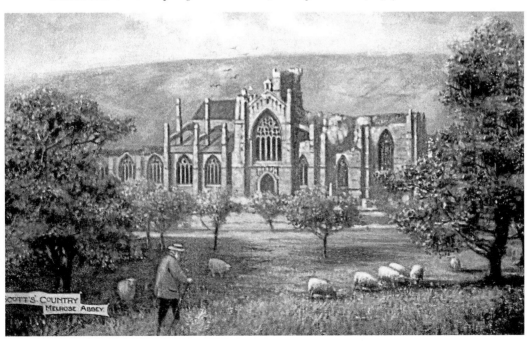

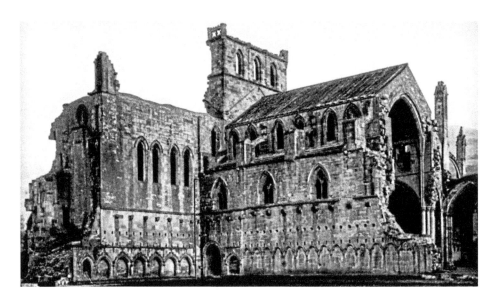

St Mary's Abbey, Melrose II

St Mary's Abbey at Melrose was founded in 1136 as the first Cistercian monastery in Scotland at the request of David I. The monks were from Rievaulx Abbey in North Yorkshire. The abbey church was dedicated on 28 June 1146 and the other buildings were constructed over the next fifty years – although most of the existing structure dates from the rebuilding, after it was burnt by the English in 1385.

The king intended that the new abbey should be on the site of an earlier seventh-century monastery founded by and dedicated to St Aidan, which was around 2 miles east of the current abbey at Old Melrose (called Mailros at the time), in a bend of the Tweed, and which was destroyed by Kenneth MacAlpin, King of the Scots, in 839. However, the monks considered that the farmland in the vicinity of the old monastery was inadequate for their purposes and selected the site upstream at what was then known as Little Fordell. The monks developed agriculture in the area – Melrose wool was sold all over northern Europe – and the town that developed around the abbey became known as Melrose.

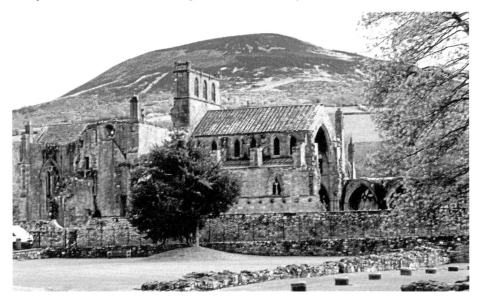

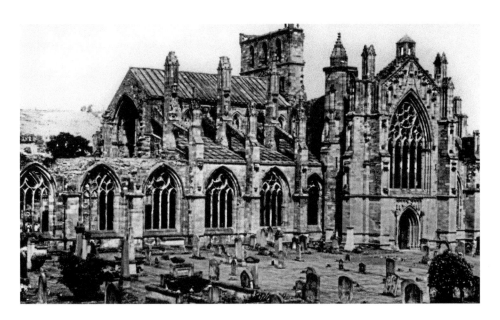

St Mary's Abbey, Melrose III

Melrose's strategic location on one of the main routes from England made it a target for invading English armies and it has a long history of destruction and rebuilding. In 1322, the town and much of the abbey were destroyed by the army of Edward II; in 1385 it was the turn of the army of Richard II; in 1544 the abbey was badly damaged during the period of the Rough Wooing by Henry VIII's army; and finally it was bombarded by Oliver Cromwell's army during the English Civil War. The abbey was looted at the start of the Reformation in 1561 and fell into disrepair.

In 1610, the nave of the abbey church was converted into Melrose's parish church and was used until 1810, when a new church was erected in the town. In 1822, Sir Walter Scott and the Duke of Buccleuch were involved in work to preserve the ruins of the abbey and it was taken into state care in 1918.

In accordance with his wishes, King Robert the Bruce's heart was buried at Melrose Abbey and its location is marked by a stone plinth.

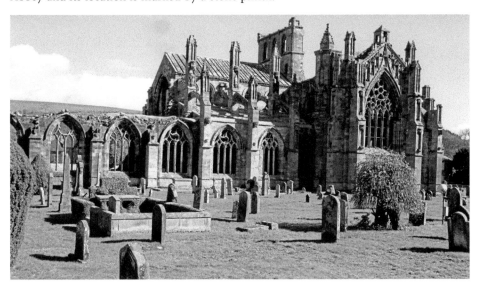

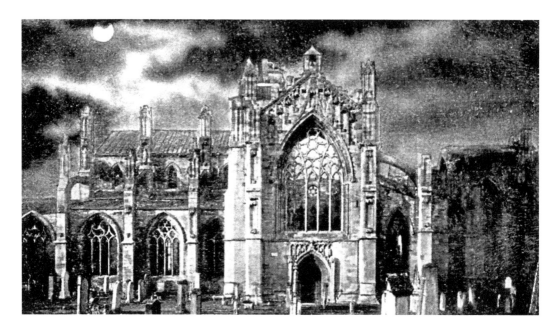

St Mary's Abbey, Melrose IV

'If thou would'st view fair Melrose aright, go visit it by the pale moonlight.'

('Lay of the Last Minstrel', Sir Walter Scott)

The abbey now comprises the fairly complete ruins of the large Gothic abbey church. It is renowned for its profusion of delicate stone carving – including a bagpipe playing pig. The inscription, '*Be halde to ye hende*' ('Keep in mind, the end, your salvation'), on one of the abbey's stairways has been adopted as the motto of Melrose.

Parts of the foundations of the domestic buildings remain to the north of the abbey. These were located closer to the river and the monks constructed a canal 2 km (1.2 miles) long to channel water for the river.

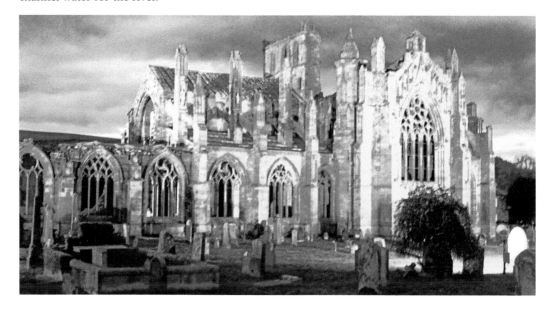

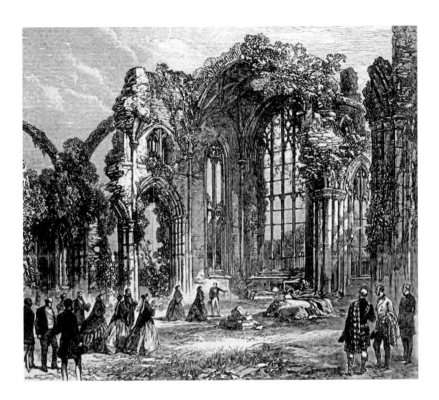

Queen Victoria at Melrose Abbey

'The position of Melrose is most picturesque, surrounded by woods & hills. Drove straight to the Abbey, walked about the very fine ruins, some of the architecture and carving being in a beautiful state of preservation. David I described as a "sair saint" originally built the Abbey. We saw where under the High Altar Robert Bruce's heart is said to be buried, also the tomb of Alexander II and of the celebrated Wizard Michael Scott.' (*Queen Victoria's Journal Entry*, Thursday 22 August 1867)

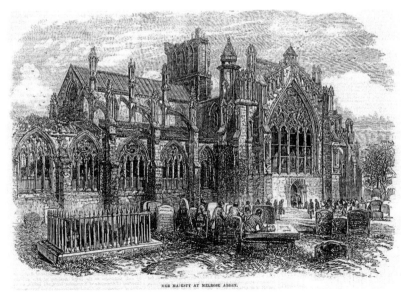

HER MAJESTY AT MELROSE ABBEY.

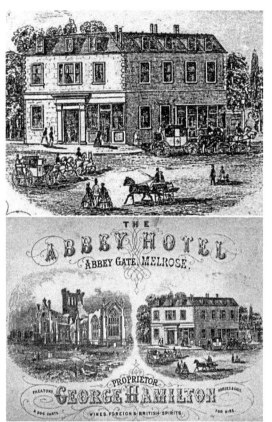

The Abbey Hotel, Melrose

The Abbey Hotel was located in the western grounds of the abbey and some of the rooms must have had great views of the church. It was demolished in 1948, which would have opened up the view of the abbey and must have been welcomed. The Victorian advert for the hotel gives the address as Abbey Gate and the proprietor as George Hamilton. It notes that phaetons, dog carts, horses and gigs were available for hire. A phaeton was an open four-wheeled horse-drawn carriage. The hotel was demolished in 1948.

'The empty Abbey Hotel, which stood before the west end of the Abbey church and thereby masked the view, was purchased and demolished, principally for a needful improvement of the amenity, but also in the hope that beneath it might be recovered further abbey remains. By this removal the site has been enormously improved and expectations of further discoveries gratified.' (*Berwickshire News*, 5 August 1952)

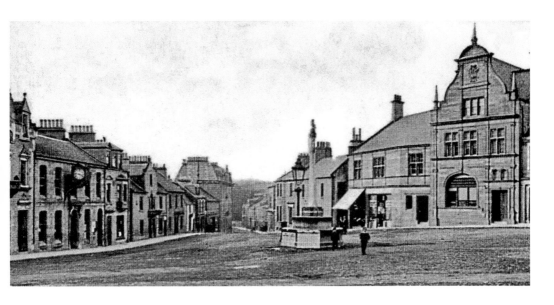

Melrose Market Square I

'Melrose is an antique little town, in a charming situation on the south bank of the Tweed, at the base of the Eildon Hills. Of late years it has been much improved and enlarged. In the town are two excellent and comfortable hotels, where post horses and carriages of all kinds can be obtained; there are likewise several inns. The population of the parish is around 4,500. Melrose is sheltered on every side by hills, the most remarkable of which are the Eildons, the Trimontium of the Romans.' (*Rutherfurd's Guide to Melrose*, 1850)

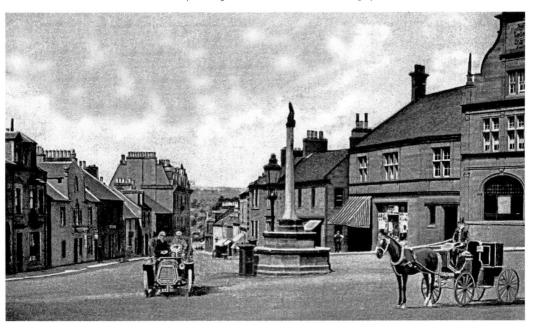

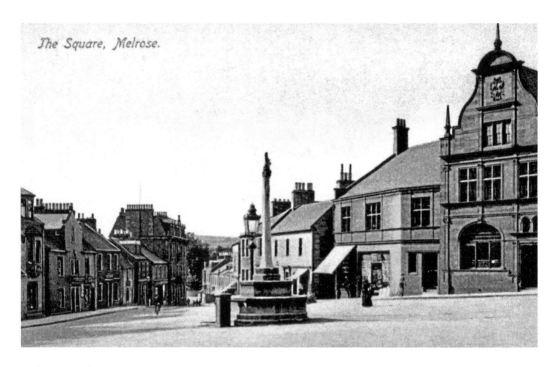

The Square, Melrose.

Melrose Market Square II

Melrose is attractively centred around Market Square with the High Street running westwards. The distinctive tall red sandstone building with the round headed gable was built for the British Linen Bank and dates from 1897 – it is now the Royal Bank of Scotland. The British Linen Bank was established in 1746 to promote the Scottish linen industry.

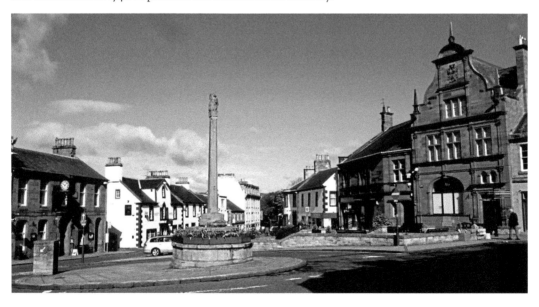

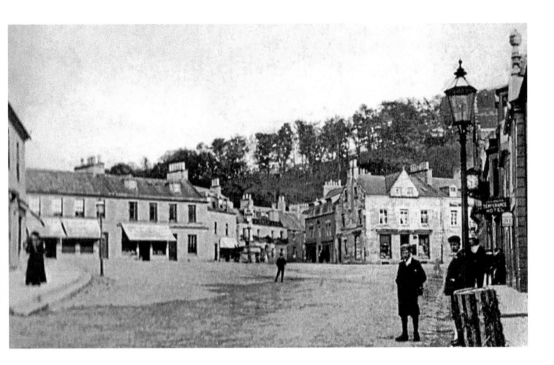

Melrose Market Square III

These two images of Market Square from the High Street reflect the emerging importance of the motorcar. Lines have been painted in the middle of the square to define a parking area in the more recent image.

Anderson's Temperance Hotel has changed to Burt's Hotel in the time between the two images. The 1845 Statistical Account noted that there were 'no less than thirty public houses in the parish of Melrose which had a pernicious effect on the morals of the people'.

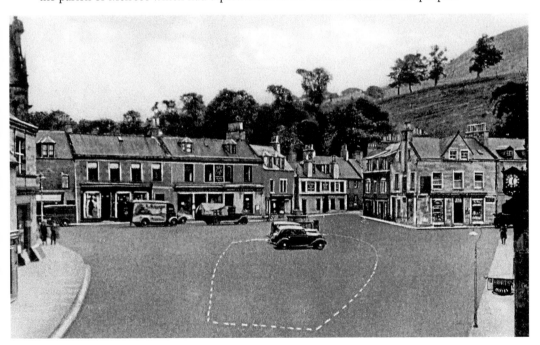

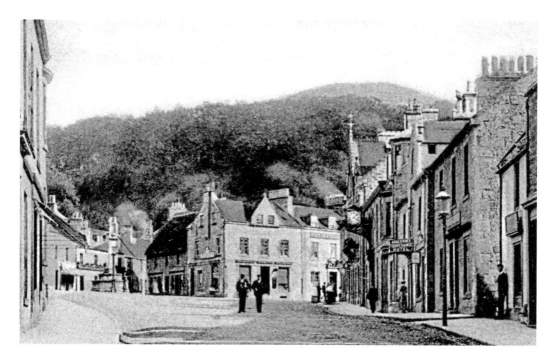

Melrose Market Square IV

The Ormiston Institute was a gift to Melrose from Charles Waller Ormiston. It is used by the Trimontium Trust as a museum relating to the Roman occupation of the area. The large cast-iron clock on an ornamental bracket is dedicated to the memory of John Meikle, a local physician and surgeon.

The adjoining building with the ornate balcony at first-floor level is Melrose's former Corn Exchange. The initials DC and date 1863 on the lintel of the central window denote the architect David Cousin and the date of completion of the building.

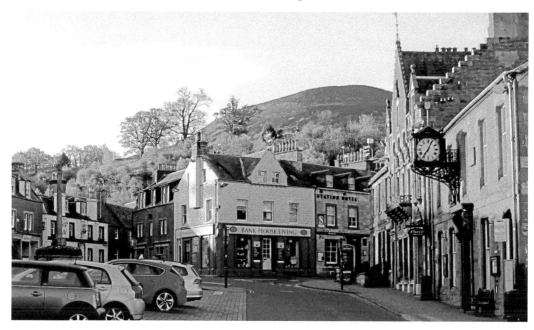

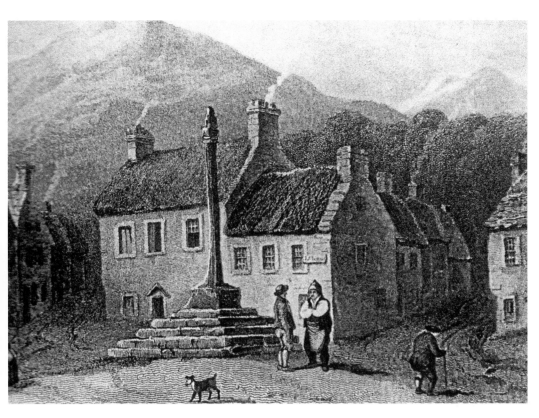

The Pant Well, Melrose

These images show Melrose's Pant Well beside the mercat cross on Market Square. The well provided a water supply for the town from 1839 to 1859.

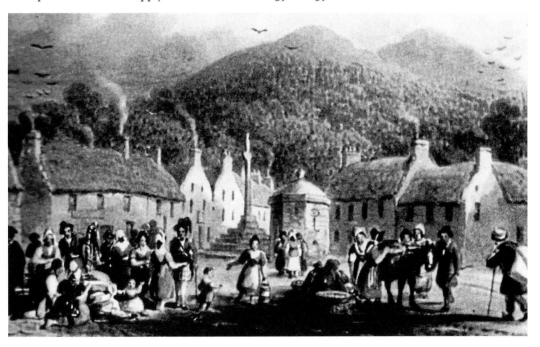

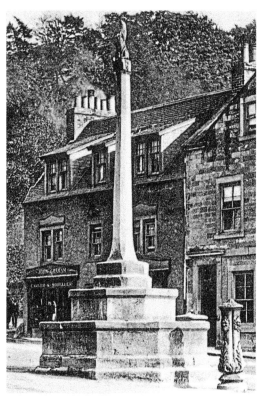

Melrose Mercat Cross

Mercat crosses were a symbol of a town's right to hold a market – an important privilege. The cross was the place where market stalls were set up, where proclamations were read and public punishments carried out. Melrose's original mercat cross stood in front of the abbey gatehouse and was moved to its current location in 1645. It consists of a tiered octagonal base, which replaced the original stepped plinth in 1861; a shaft, which dates from 1988; and the unicorn capital, which is a replacement dating from 1990.

The cross was the starting point of Melrose's annual Fastern's E'en (Shrove Tuesday) football match (the Ba' Game) between the married and unmarried men of the town. The game was played along the main street from early afternoon until evening. The game was banned in 1901 due to injuries and damage to buildings. The earlier image shows the small iron fountain that replaced the Pant Well.

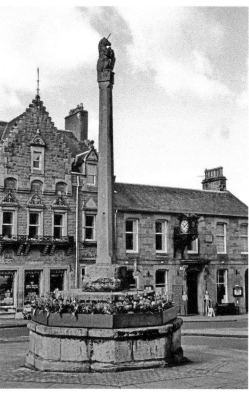

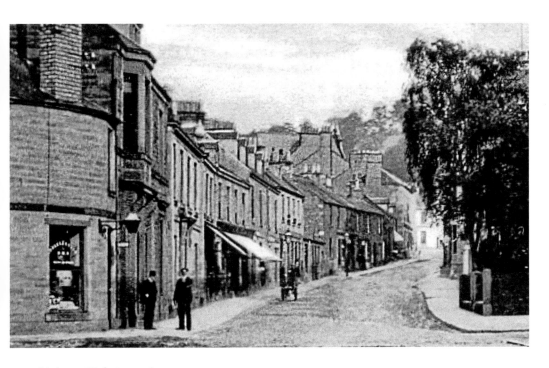

Melrose High Street I

Views looking east along the High Street from its junction with Buccleuch Street. Apart from the impact of motor vehicles, there has been little change in the appearance of the High Street in the 100 years that separates these images.

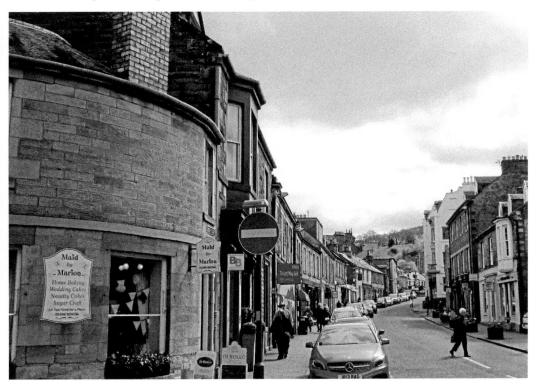

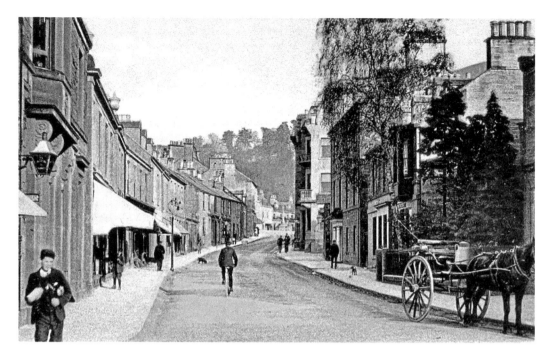

Melrose High Street II

The older image shown here really captures the peaceful character of Melrose on what looks like a beautiful sunny day in the 1900s. A horse and trap wait patiently on the street, a couple of dogs are out for a wander, a cyclist makes his way up the hill towards Market Square, and a young lad, in the left foreground, stares directly into the camera. The mercat cross can be seen in the background.

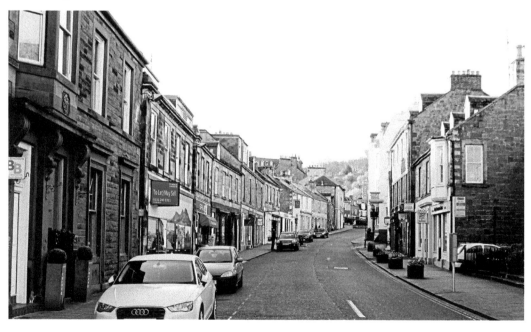

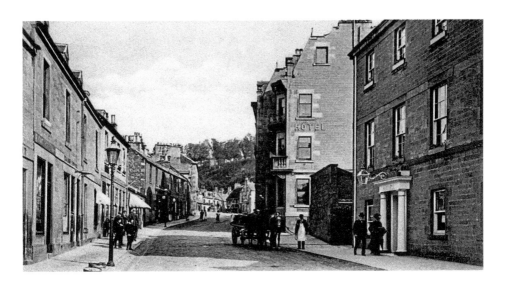

Melrose High Street III

Views further east along the High Street. The George & Abbotsford Hotel and the King's Arms are on the right. The George & Abbotsford Hotel was formerly the George Inn, an old coaching inn, where William and Dorothy Wordsworth stayed on their visit to Melrose in 1803.

'After breakfast we went out, intending to go to the Abbey, and in the street met Mr. Scott, who gave us a cordial greeting, and conducted us thither himself. He was here on his own ground, for he is familiar with all that is known of the authentic history of Melrose and the popular tales connected with it..... Dined with Mr. Scott at the inn; he was now travelling to the assizes at Jedburgh in his character of Sheriff of Selkirk, and on that account, as well as for his own sake, he was treated with great respect, a small part of which was vouchsafed to us as his friends, though I could not persuade the woman to show me the beds, or to make any sort of promise till she was assured from the Sheriff himself that he had no objection to sleep in the same room with William.' (*Recollections of a Tour Made in Scotland, AD 1803*, Dorothy Wordsworth – journal entry for Monday, 19 September 1803)

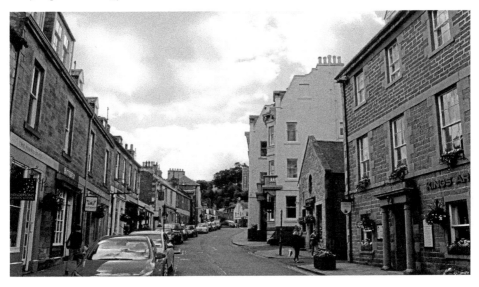

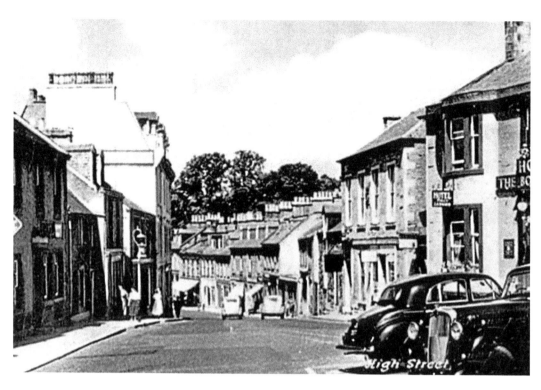

Melrose High Street IV
Views looking west along Melrose High Street from Market Square. The Bon Accord Hotel was opened in 1948 after conversion of an existing house; it is now the Townhouse.

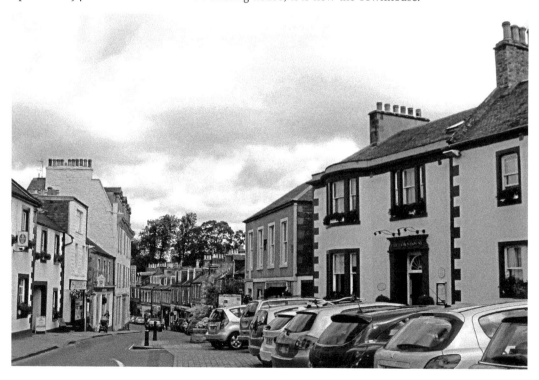

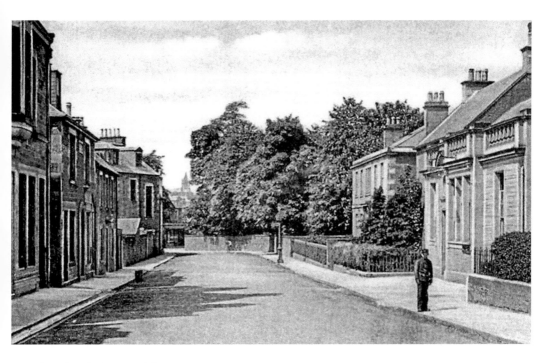

Buccleuch Street, Melrose

Apart from the cars there has been little change in Buccleuch Street over the 100 years that separates these images, although the trees have grown considerably. A postman is standing outside the post office in the older image. The new post office was formally opened on 11 March 1902. The town council and a number of invited guests assembled at the Town Hall and marched in procession to the new post office, where they were met by Mr Wood, the postmaster, and his staff. The provost then unlocked the door and declared the post office open. The company sang 'God Save the King' and the provost sent a telegram to Lord Londonderry, the postmaster-general. The interior was examined and the company headed off to the King's Arms Hotel for a cake and wine banquet. Eight postmen were employed with 14,393 letters being dealt with daily and there were three deliveries daily in the town.

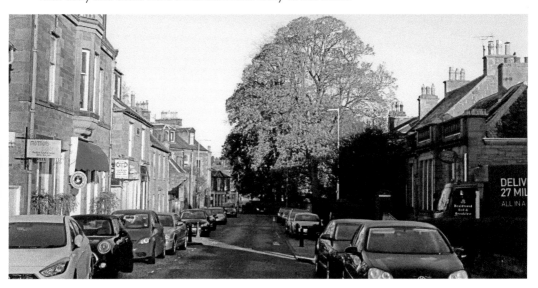

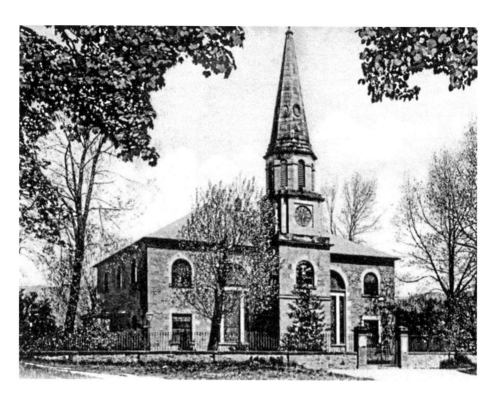

Melrose Parish Church, Weirhill, St Mary's Road

The nave of Melrose Abbey functioned as Melrose's parish church from 1618 to 1810. In 1810, a new parish church was opened at Weirhill. This was badly damaged by a fire in 1908. The present church opened in 1911, incorporating the tower and spire from the old church.

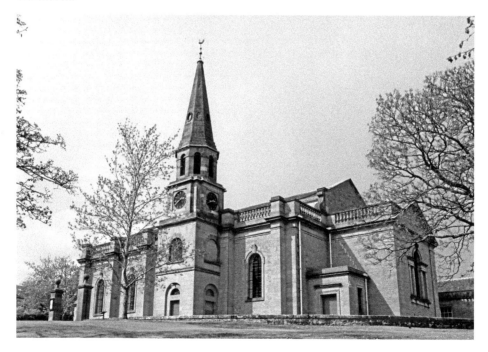

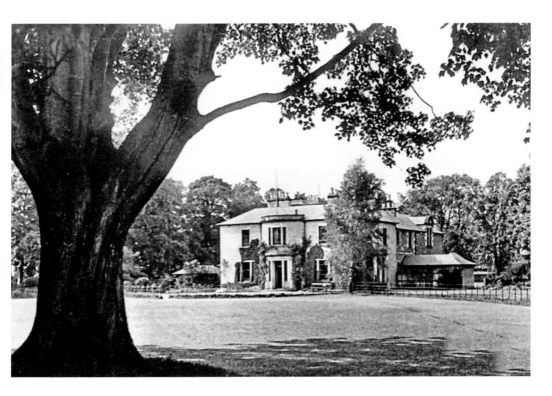

St Mary's School, Abbey Park, Melrose

St Mary's School was founded in 1895 to provide an education for boys that was strong on academic achievement and sporting excellence – the school has since produced seventeen Scotland rugby union internationals. It has been co-educational since 1976.

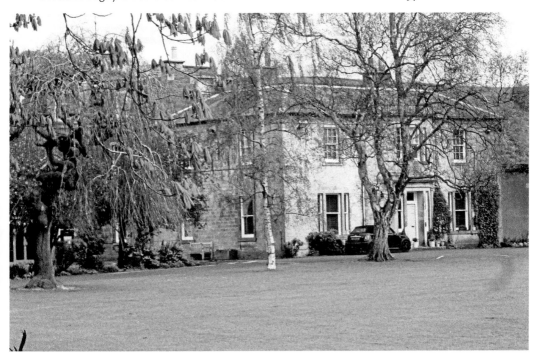

Greetings from MELROSE

Melrose Sevens

Melrose Rugby Ground stands on an area of marshy ground known as the Greenyards, which was drained for use as a rugby pitch in 1887. It was gifted to the town by Charles Ormiston, a local seed merchant. It is the home of Rugby Sevens, which was invented by Ned Haig (1858–1939), a local butcher and Melrose player. It was first played in the town in 1883. The Melrose Sevens tournament is held on the second Saturday of April. It is a prestigious event in the rugby world and attracts international teams and supporters to Melrose.

'Practically on the eve of the start of the spring 'sevens', the death has occurred at Melrose of the man in whose fertile brain the idea of an abbreviated game was born. He was Ned Haig, and he died at home in Melrose at the age of 82. Haig, who was a native of Jedburgh, went to Melrose when a youth, and quickly took to the rugby game to become one of the best backs in the Borders. When the finances of Melrose club were at a low ebb it was Haig who thought out the plan of the abbreviated tournament which today is popular wherever rugby is played. It was in 1883 that the 'sevens' were inaugurated on the famous Greenyards and the promoting club were the winners. The annual pilgrimage to the Greenyards will be a lasting memorial to Ned Haig.' (*Edinburgh Evening News*, March 29 1939)

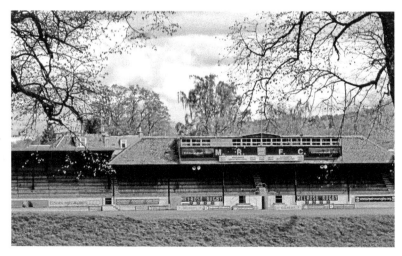

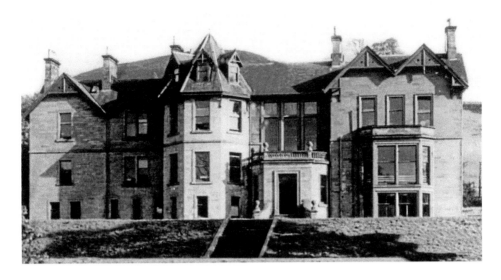

Priorwood House, Former Melrose Youth Hostel

The red-sandstone Priorwood House dates from 1815 and was built for a General Goudie. It was purchased by the Curle family in the mid-nineteenth century. James Curle (1862–1944) was a local solicitor and amateur archaeologist who was responsible for the first excavations of the Roman fort site at Trimontium between 1905 and 1910, which brought him international fame. In 1875, it was substantially reconstructed by Peddie and Kinnear. It was used as military hospital during Second World War.

The building opened as the Melrose Youth Hostel in 1947. The Scottish Youth Hostel Association was formed in Edinburgh in 1931 with the aim of 'helping all, but especially young people of limited means living and working in industrial and other areas, to know how to use and appreciate the Scottish countryside and places of historic and cultural interest in Scotland, and to promote their health, recreation and education, particularly by providing simple hostel accommodation for them on their travels'. The first hostel was opened at Broadmeadows in the Borders in 1931. By 1936, there were forty-eight hostels with a membership of nearly 12,000. The Melrose hostel closed in 2011 and there has since been an ongoing debate about its future.

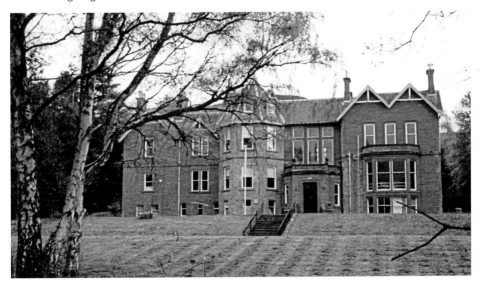

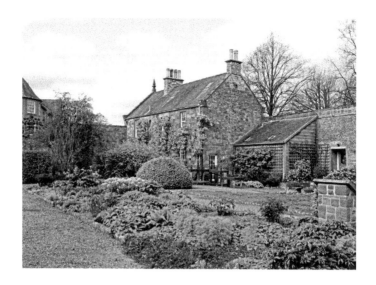

Melrose, Priorwood and Harmony Hall

Priorwood Garden was once part of the precinct of Melrose Abbey and later the walled garden of Priorwood House. The initials of James and Blanche Curle, who owned the house, are over the entrance gate to the gardens. The garden is surrounded on three sides by high walls; the wall along Abbey Street is stepped with large semi-circular scallops containing twentieth-century wrought-iron work, probably designed by Edwin Lutyens. The garden is renowned for its dried flowers and the historic varieties of apple trees in its orchard. The cottage in the garden dates from 1875. The garden is in the care of the National Trust for Scotland

Harmony Hall is a finely detailed elegant Regency town house that dates from 1807. The tranquil garden is enclosed by a high stone wall. The house was built for Robert Waugh, a local joiner who left Melrose and made a fortune as a plantation owner in Jamaica. When he returned to Melrose a rich man, he named his new house after his Caribbean plantation, which was the source of his wealth. However, it seems that his affluence did not make him happy. Melrose disapproved of him because of his links to the slave trade and he was known as 'Melancholy Jaques' – a 'dour and pessimistic' recluse.

The house was bequeathed to the National Trust for Scotland in 1996 and it has since been restored as holiday accommodation and for functions.

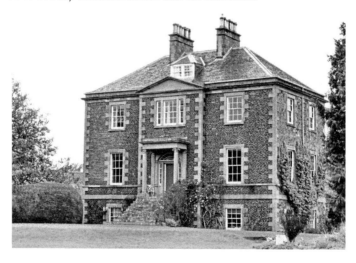

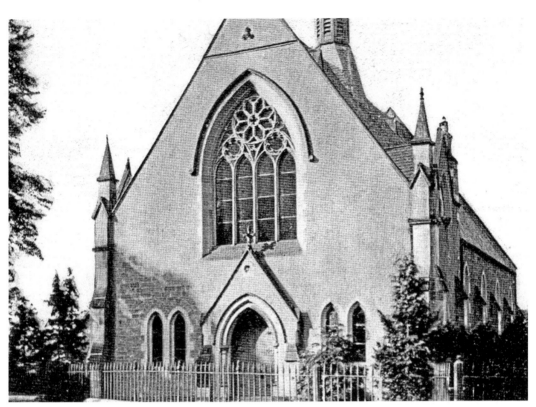

Melrose Former Congregational Church, Waverley Road
This building was erected as the Melrose Congregational Church in 1878. It was closed as a church in 1930 and has since been a cinema, an antique shop, a coal merchant's and offices for Scottish Water and NHS Borders. The changes of use over the years have taken their toll on the architecture of the building.

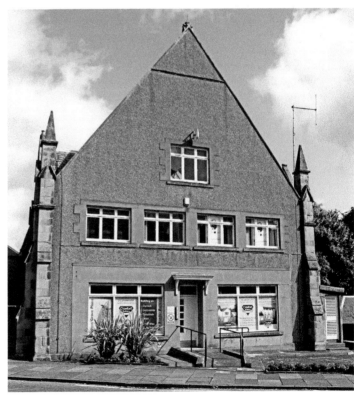

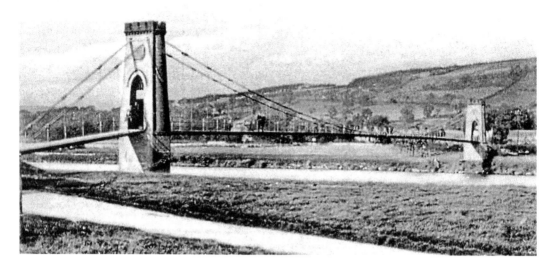

Melrose and Gattonside Suspension Footbridge

The Gattonside Suspension Bridge spans 90 metres over the Tweed and links Melrose with the village of Gattonside on the north side of the river. It opened on 26 October 1826 and is one of the oldest suspension bridges in Scotland. It enabled the people of Gattonside to attend the parish church in Melrose more easily.

It replaced a ford downstream from the bridge. A box of stilts was provided at each side of the ford for people to use when crossing the river – a number of people drowned at the ford and the bridge was a substantial improvement in terms of safety and convenience. It seems that some people became so expert at the stilt crossing that they could cross 'with the greatest of ease'.

Plaques on the bridge note that it was manufactured and erected by Redpath, Brown & Co. of Edinburgh in 1826, repaired by Redpath Brown in 1928 and strengthened and reconstructed by Borders Regional Council in 1991.

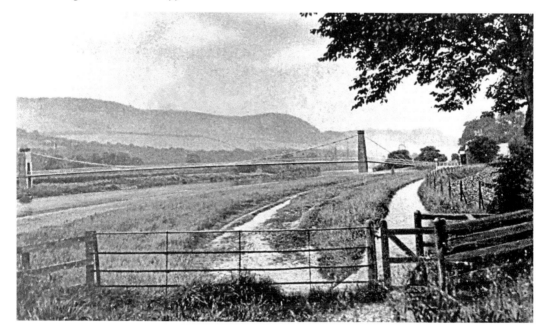

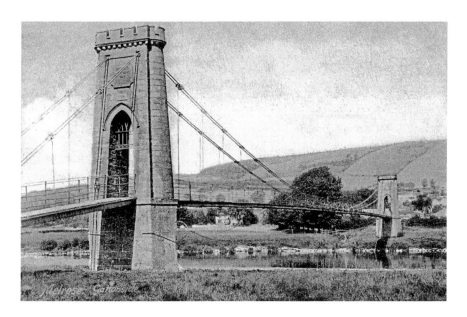

Melrose and Gattonside Suspension Footbridge

'Many a storm has swept down the vale of Tweed and dashed against the pillars and iron work of the bridge since it opened in 1896; on many a stormy day and night has the bridge heaved and tossed like a ship in distress, and its chains creaked and shrieked like a living thing, when to cross it was not only a daring deed but a dangerous proceeding.' (*Southern Reporter*, 12 February 1903)

The house on the Melrose side of the bridge was the former toll house. Charges were ½*d* per crossing, or 3*d* for a week's pass. Notices on the bridge still detail the conditions for use of the bridge. These note that it is an offence for more than eight people to be on the bridge at the same time, that horses and cattle should not cross the bridge and that loitering on the bridge or making it swing were prohibited.

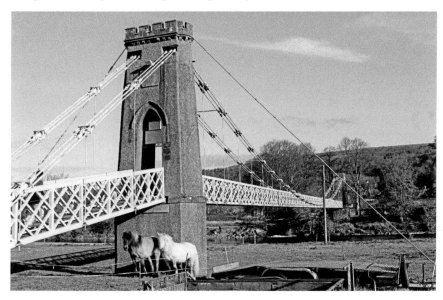

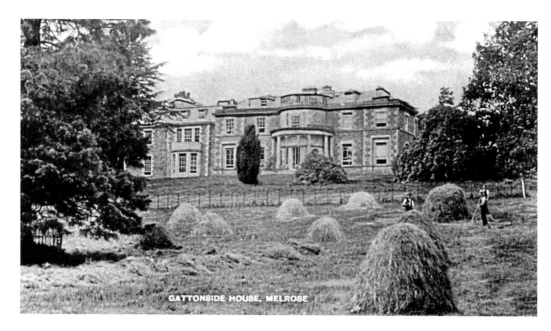

GATTONSIDE HOUSE, MELROSE

Gattonside House

Gattonside is located on the north side of the River Tweed, linked to Melrose on the south side by a footbridge. Gattonside House dates from 1808–11 and was originally built for Sir Adam and Lady Ferguson. It was acquired by retired banker George Bainbridge who employed eminent local architect John Smith of Darnick in 1824 to enlarge it into a fine four-storey classical villa. It was further enlarged by Robert Lorimer in the early twentieth century. The chapel adjoining the east end of the house was built almost single-handedly by Brother Columba Farrelly over a fifty-year period (1921–72).

The building was the administrative headquarters of the Brothers of Charity for most of the twentieth century and operated as St Aidan's Care Home. The building was empty at the time of writing and planning permission has been approved for its conversion to residential use.

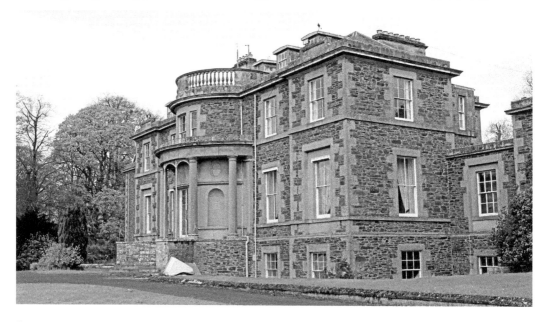

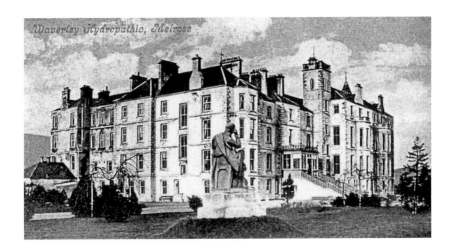

Waverley Hydropathic

The Waverley Hydropathic Institution opened in 1871. James Campbell Walker, the architect of the building, used pioneering construction methods. It is probably the earliest mass concrete building in Scotland, which was considered to 'compare very favourably with the ordinary methods of stone or lime or brick building'. The first medical superintendent of the hydro was Alexander Munro. It was a huge building forming a square with 43 metre (140 feet) sides, a central court and 140 bedrooms. It is now known as the Waverley Castle Hotel. The marble statue is of Sir Walter Scott.

'A hydropathic establishment on a large scale has been partly, and will in a short time be fully opened at Melrose. It is called the Waverley, and is situated about equidistant from Abbotsford and the town of Melrose, amidst the beautiful scenery of the Tweed. It is wholly built of concrete, applied by the Newcastle Concrete Company, but the gravel which is used in the walls was procured form the hills adjacent to the building. The building is a very handsome structure, and contains 140 bedrooms. It has a large lecture room, billiard rooms, dining rooms, and all the appliances of a most complete establishment. Its baths for the application of the hydropathic treatment are very superior, and its Turkish baths are considered to be the best in the kingdom.' (*Berwickshire News*, 18 July 1871)

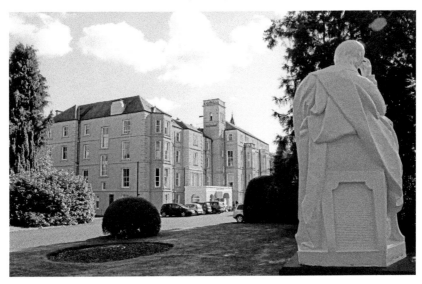

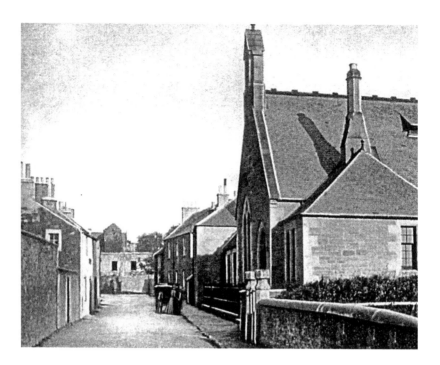

Darnick

The village of Darnick, a mile west of Melrose, was first recorded in the early twelfth century, and its name has changed from Dernewic, Dernwick and Darnwick to the present Darnick, derived from two Anglo-Saxon words: '*derne*' meaning 'hidden' and '*wic*', 'a dwelling'.

The building to the right in the images is the Smith Memorial Hall. It was gifted by Violet Smith of Darnick and is dedicated to the memory of John Smith, a timber merchant from Melbourne, and the Australian philanthropist Helen Macpherson Smith, who was born in Darnick. The hall is a venue for community activities and has recently been refurbished. The village's war memorials are built in to the front of the building.

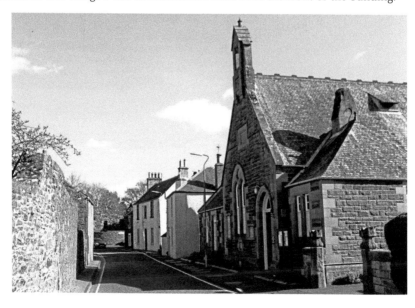

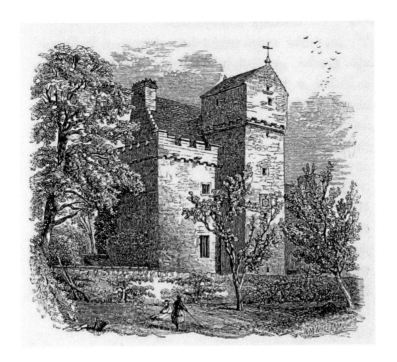

Darnick Tower I

The present Darnick Tower dates from 1569 and replaced an earlier fifteenth-century peel tower, which was partly destroyed by the Earl of Hereford in 1545. The tower was built by the Heiton family and was the family's ancestral home, until its recent sale. The bull's head crest of the Heiton family and the initials AH and KF, for Andrew Heiton and his wife Kate Fisher, and the date 1569 are displayed on the building.

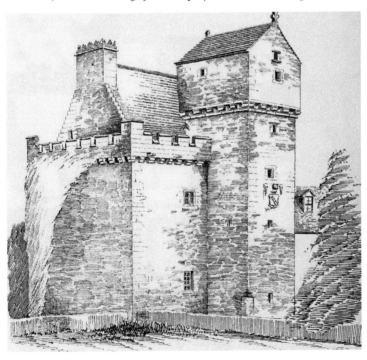

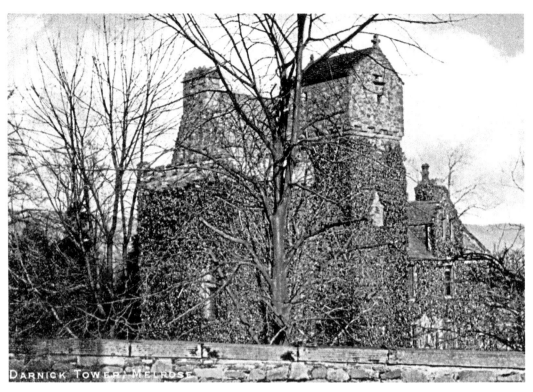

DARNICK TOWER, MELROSE

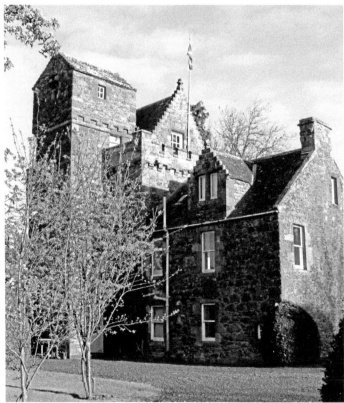

Darnick Tower II
Skirmish Hill by Darnick was the site of a battle on 18 June 1526, which took place between the Scotts of Buccleuch and the Kerrs of Ferniehirst, trying to intercept James V, who was then under the guardianship of Archibald Douglas, 6th Earl of Angus. James V is said to have viewed the battle from the tower

Andrew Currie, the renowned local sculptor, had a workshop in the grounds of Darnick Tower from around 1859 onwards. Among his work are: the Mungo Park statue in Selkirk, the Ettrick Shepherd at St Mary's Loch, the Bruce Monument at Stirling, and figures on the Scott Monument in Edinburgh.

The Rhymer's Stone

'At Eildon Tree if you should be
A bridge over Tweed you there may see.'
(Prediction ascribed to
Thomas the Rhymer)

The Rhymer's Stone is situated to the south-east of Melrose. The inscription on the stone reads: 'This stone marks the Eildon tree where legend says that Thomas the Rhymer met the Queen of the fairies and where he was inspired to utter the first notes of the Scottish muse'. The legend is that Thomas fell asleep under the tree, met the Queen of the fairies, and was transported to the Court of the fairies for seven years. When he returned to the mortal world, he had the power of prophecy (he was also known as True Thomas), poetic talent and the inability to tell a lie. The legend is the subject of folktales, a ballad and was expanded on by Sir Walter Scott in his Minstrelsy of the Scottish Border. It seems that there really was a Thomas Rymour from Erceldoune, the present day Earlston, in the 13th century. The stone was erected by the Melrose Literary Society in 1929

Thomas predicted that a bridge over the River Tweed would in the future be visible from the Eildon Tree. In 1865, this prediction was fulfilled when the Leaderfoot Viaduct was built. It can just be seen in the lower photo, which is taken from the viewpoint near the stone.

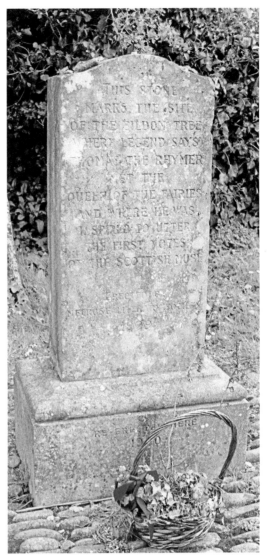

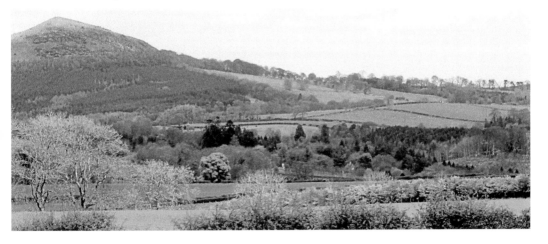

85

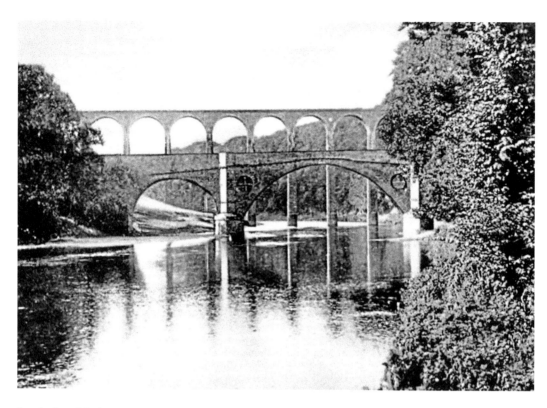

Leaderfoot Viaduct

The Leaderfoot Viaduct (Drygrange Viaduct) opened in 1865 and consists of nineteen spans with semi-circular arches. Its towering height and elegantly slender proportions make it an impressive landmark. The viaduct linked the Berwickshire Railway's 'Waverley Route' between Edinburgh and Hawick, to Duns and Reston on a single track at a height of 38 metres (126 feet) The line closed to passenger traffic on 13 August 1948 after it was cut by floods, and closed to freight in 1966. It was renovated in 1995 and is now in the care of Historic Environment Scotland.

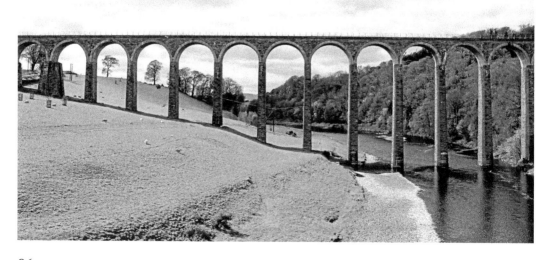

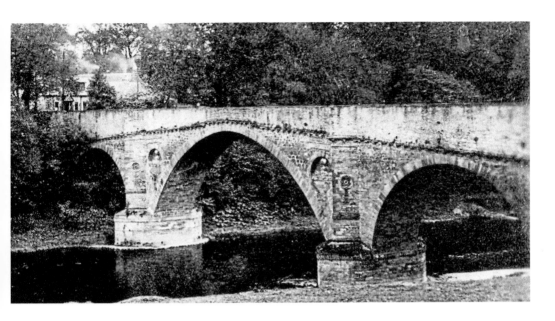

Drygrange Bridge

The substantial and elegant four-span Drygrange Old Bridge opened in 1780 and replaced a ferry as part of an improvement to a turnpike road (its alternative name, the Fly Boat Bridge, refers to the earlier ferry). Alexander Stevens, the bridge designer, employed innovative construction methods and the central span of 31 metres (102 feet) is considered exceptional for its date. In 1974, it was replaced by a new bridge carrying the A68 over the Tweed. It is close to the Roman settlement of Trimontium and the Drygrange Bridge with its modern successor and the Leaderfoot Viaduct are known as the Tripontium.

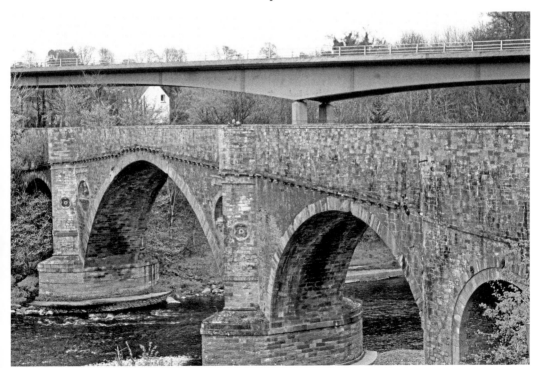

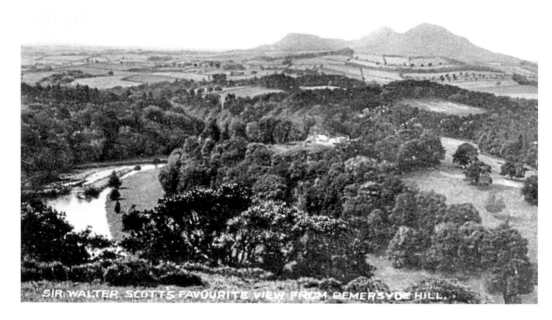

SIR WALTER SCOTT'S FAVOURITE VIEW FROM BEMERSYDE HILL.

Scott's View

These views look across a loop of the Tweed to the site of Old Melrose and the original abbey with the Eildon Hills as a backdrop. It was one of Sir Walter Scott's favourite views. Scott stopped at this point so often on the way to Abbotsford that his horses would halt without command. It is said that the horses that pulled Scott's hearse from Abbotsford to his burial place at Dryburgh Abbey stopped at this spot to give their master a last look, as they had done so many times when Scott was alive.

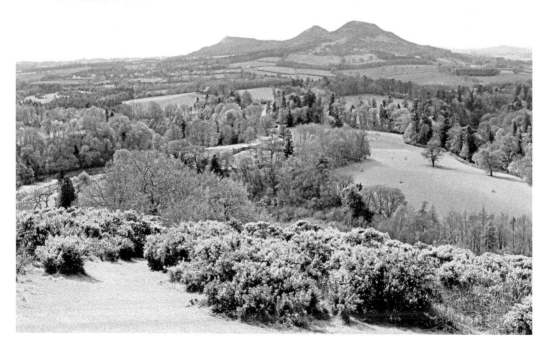

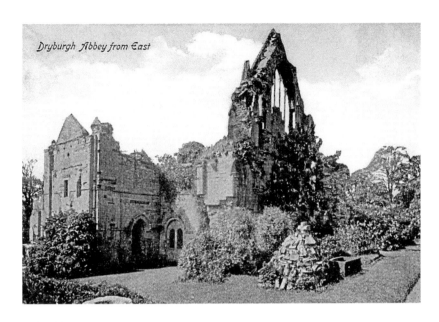
Dryburgh Abbey from East

Dryburgh Abbey

The picturesque ruins of Dryburgh Abbey lie in a tranquil and secluded spot on a horseshoe bend of the Tweed, a few miles downstream from Melrose. The abbey was founded in 1150 by canons of the Premonstratensian Order (White Canons) under the patronage of Hugh de Moreville, the Constable of Scotland and Lord of Lauderdale. Only a fragment of the abbey church, dedicated to St Mary, remains on the highest ground. However, a substantial amount of the domestic architecture can still be seen – the chapter house, parts of the dormitory and cloisters.

Dryburgh's location meant it often became caught up in the wars between England and Scotland. It was burned by English troops in 1322, 1385 and 1544. The architecture reflects periods of destruction and rebuilding. In 1786, the abbey was purchased by the Earl of Buchan, a founder of the Society of Antiquaries of Scotland, who created a formal garden as a setting for the abbey.

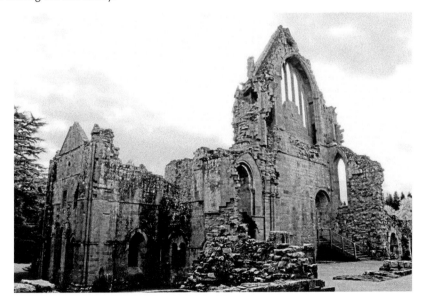

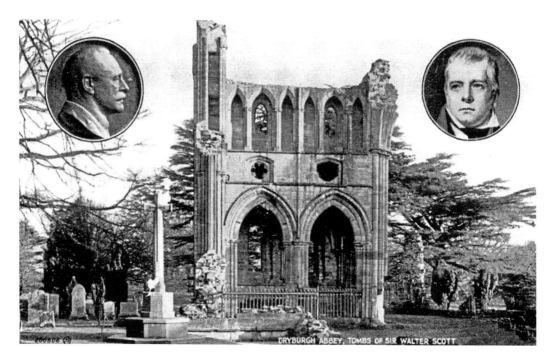

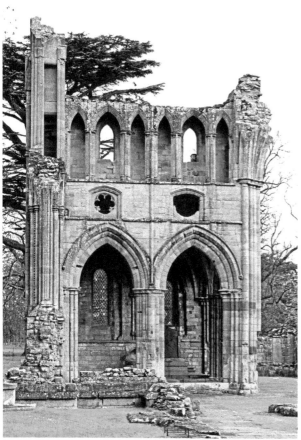

Dryburgh Abbey, Sir Walter Scott and Earl Haig

The tombs of Field-Marshal Earl Haig (1861–1928) and Sir Walter Scott (1771–1832) are in chapels in the north transept of the abbey church at Dryburgh. Haig was born in Edinburgh's Charlotte Square in 1861. He commanded the British Army in France for most of the First World War, and his name has become associated with the carnage of the conflict. In 1921, Earl Haig established the Royal British Legion and the Earl Haig Fund to assist ex-servicemen. Haig died in London from a heart attack, aged sixty-six, on 29 January 1928 and was given an elaborate funeral on 3 February. His grave is marked by a simple standard Commonwealth War Graves Commission white headstone.

Sir Walter Scott died at Abbotsford from typhus on 21 September 1832 and was buried in the already derelict Dryburgh Abbey – a spot he had identified at an early age as his last resting place.

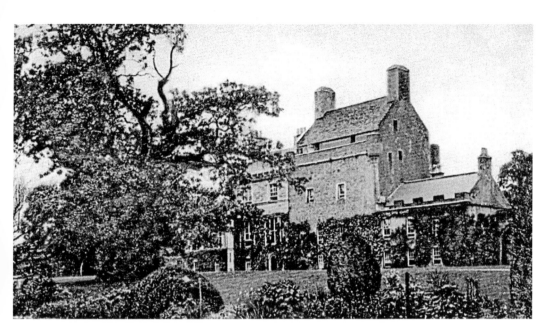

Bemersyde House

Bemersyde House lies between Earlston and Dryburgh. It is the ancestral home of the Haig family, which has links to the area going back to the twelfth century. The original tower house, which dated from the sixteenth century, was enlarged in the eighteenth century into the present mansion. The house passed out of the immediate Haig family in 1854, but was presented by the British government to Field-Marshall Earl Haig in 1921 for his service as British commander in the First World War.

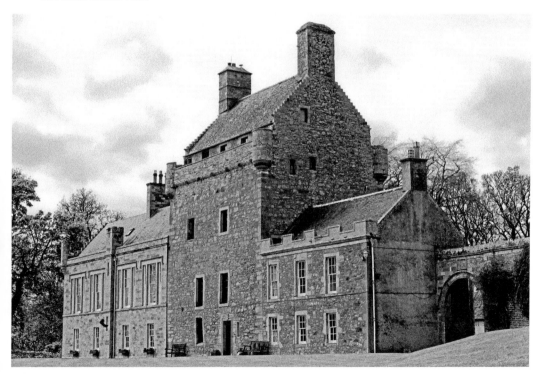

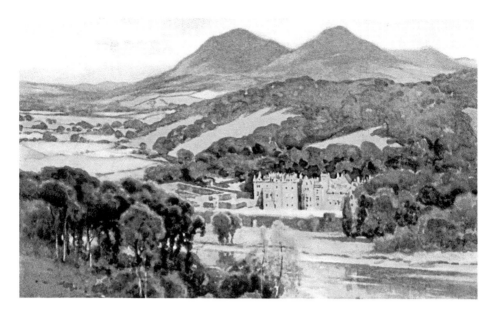

Abbotsford I

'The site of Abbotsford is eminently beautiful. The Gala Water falls into the Tweed immediately below it. Itself environed with woods, amidst which, early in the season, the gay blossoms of the lilac and laburnum glow in beauty – it overlooks the fine sweep of the river, and a beautiful meadow on the opposite bank, which almost seems as if contrived to form part of the domain. Nothing is more apt to give a full conception of the extent to which the merit of creating Abbotsford belonged to Sir Walter Scott, than the fact that its site was formerly occupied by a small farm-steading, rejoicing in the designation of Cartley-hole. Thus the heart of the romancer clung, as he said, to the place he had created, for there was not a tree that did not owe its being to him. At Abbotsford all the finest of his novels were written.' (*Menzie's Pocket Guide to Abbotsford, Melrose and the Scottish Borders*, 1855)

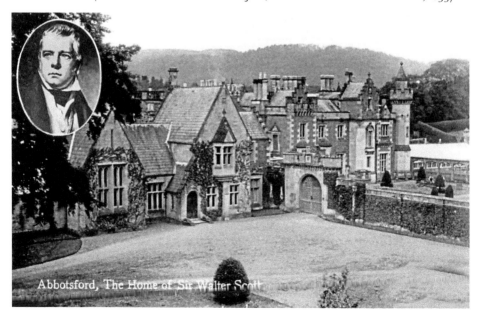

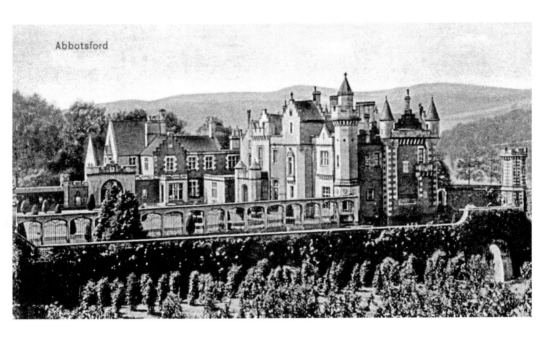

Abbotsford

Abbotsford II

Sir Walter Scott bought the farmhouse of Cartlehoyle (known locally as Clarty Hole) in 1811 along with a large area of land. He renamed it Abbotsford from a nearby ford used by the abbots of Melrose Abbey. The old farmhouse was demolished in 1822 and by 1824 had been replaced by a new house, which was adapted and enlarged over the years. Scott also had numerous salvaged architectural feature built into the building and garden walls – including the door from Edinburgh's Tolbooth. The spectacular location of the house on the banks of the Tweed is at the core of the countryside that inspired Scott's greatest works. It is considered to be one of the most important nineteenth-century buildings in Scotland and is a significant example of Scottish Baronial architecture.

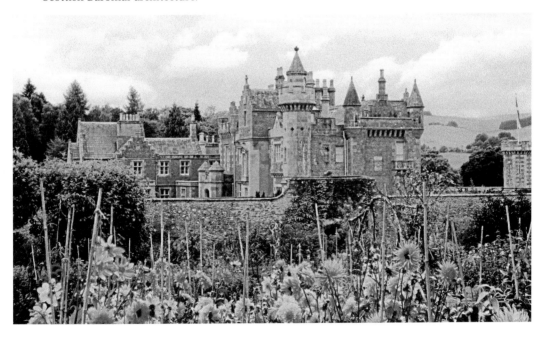

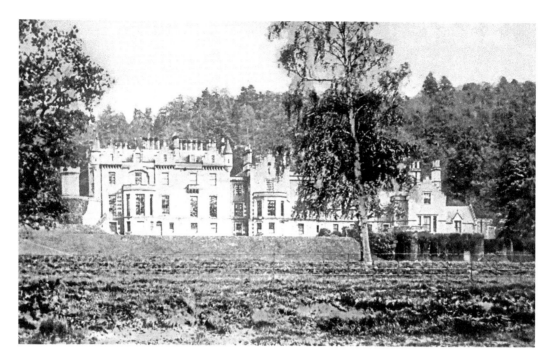

Abbotsford III

Sir Walter Scott's family continued to live at Abbotsford until 2004 and the house has been open to the public since 1833. The Abbotsford Trust was formed in 2007 following the death of Dame Jean Maxwell-Scott, the last of Scott's descendants to live in the house. The Queen reopened Abbotsford House in July 2013 following a lengthy restoration of the house. A new award-winning visitor centre also provides an account of Scott's life and cultural legacy.

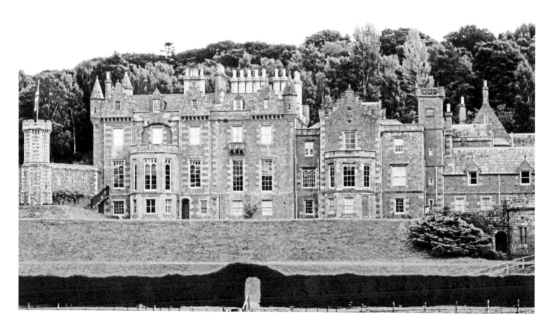

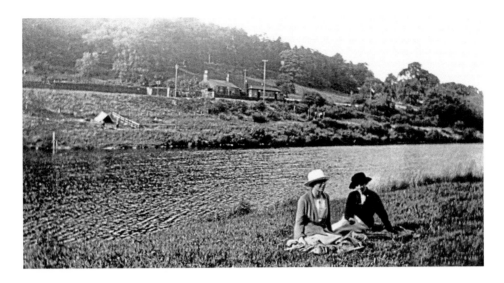

Abbotsford Ferry

The railway line from Galafoot Junction to Selkirk opened for traffic on 5 April 1856. Abbotsford Ferry (originally Boldside) was one of the intermediate stations. The station was on the north bank of the Tweed across the river from Abbotsford House. Visitors to the house arriving by train at Abbotsford Ferry station used a cable-worked ferry to cross the Tweed. The two ladies in the upper image are having a leisurely break on the banks of the Tweed with the station on the opposite side of the river. Abbotsford Ferry station closed on 5 January 1931 except for the occasional special.

The ferry crossing was not without some risk. The following tragic incident was reported as occurring on Martinmas Fair Day, November 1723, which had been chosen as the wedding day by a young farmer and his bride who travelled to Galashiels for the ceremony with friends and family. The celebrations continued all day and the wedding party returned to cross the ferry. However, the river was high, running strongly, and its normal width of 250 yards was greatly increased. The ferryman eventually took the overloaded ferry across and got a line and himself ashore, but the line snapped and the boat was swept away and capsized, drowning eighteen of the thirty-three-strong wedding party.

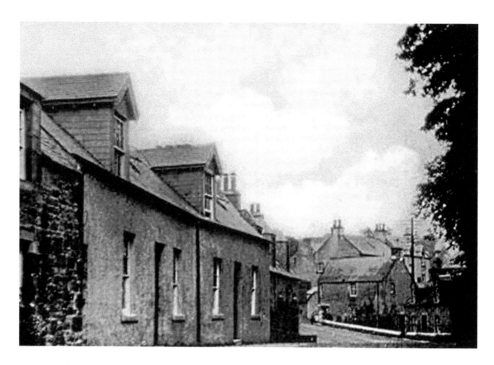

Newstead

The small village of Newstead lies around 2.1 km (1.3 miles) east of Melrose. It was located where the Roman road, Dere Street, was able to cross the Tweed and was a strategic centre during the Roman occupation at Trimontium. The prominence of the Eildon Hills allowed the Romans to send signals over long distances and the Latin name Trimontium refers to the hills. It was one of the largest Roman sites in Scotland with a number of phases of occupation from AD 79 to AD 220.

It is reputedly the oldest continually inhabited village in Scotland. The stonemasons who built Melrose Abbey stayed in the village and it is the site of the first Masonic lodge in Scotland.

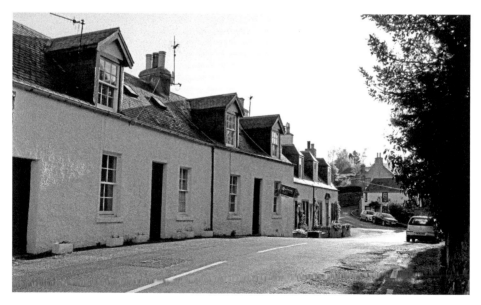